Painting People

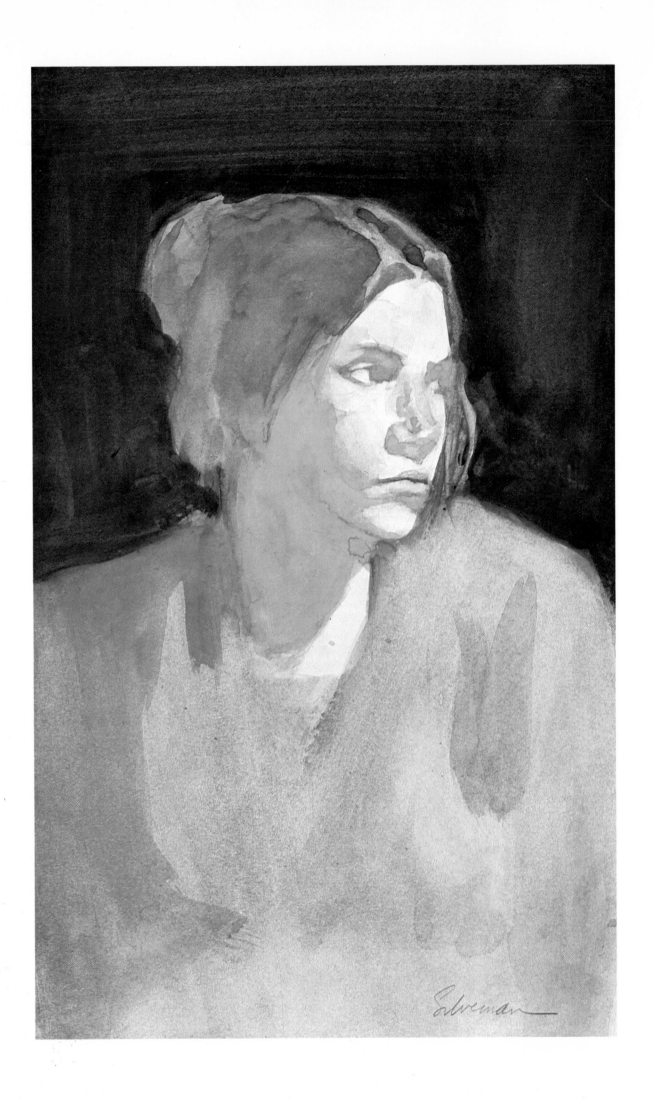

Painting People

by Burt Silverman

WATSON-GUPTILL PUBLICATIONS/NEW YORK

PITMAN PUBLISHING/LONDON

To my Father and Mother—
once again for their patience
love and trust when it
mattered the most.

FRONTIS

Apprehensive, 1974, watercolor on bristol paper, 7″ x 11″ (18 x 28 cm), courtesy FAR Gallery. The forms here are rendered loosely, with a minimal representation of the person's body. The light is focused on the head, and the black background along with the cool, almost grisaille, color is geared to dramatizing the distant anxious look in the girl's face.

First published in 1977 in the United States and Canada by
Watson-Guptill Publications,
a division of Billboard Publications, Inc.,
1515 Broadway, New York, N.Y. 10036

Library of Congress Cataloging in Publication Data
Silverman, Burt, 1928–
 Painting people.
 Includes index.
 1. Portrait painting—Technique. 2. Portrait
drawing—Technique. 3. Pastel drawing—Technique.
4. Water-color painting—Techniques. I. Title.
ND1302.S57 1977 751.4 77-8642
ISBN 0-8230-3815-7

Published in Great Britain by Pitman Publishing Ltd.,
39 Parker Street, London WC2B 5PB
ISBN–0-273-01152-9

Manufactured in Japan

First Printing, 1977
Second Printing, 1978

Acknowledgments

I would like to thank Don Holden, Editorial Director of Watson-Guptill, for his unswerving persistence in urging me to write this book and for his extraordinarily sensitive and intelligent editing of the original manuscript.

My thanks also go to Connie Buckley for her equally skillful editing, to Tony Mysak, Sidney Lipschutz, and Dan Becker for their expertise and diligence in providing many of the photographs of my work; to Mrs. Lynne Snider for her most kind cooperation; and finally to my wife, Claire, for her unfailingly perceptive criticism and loving support.

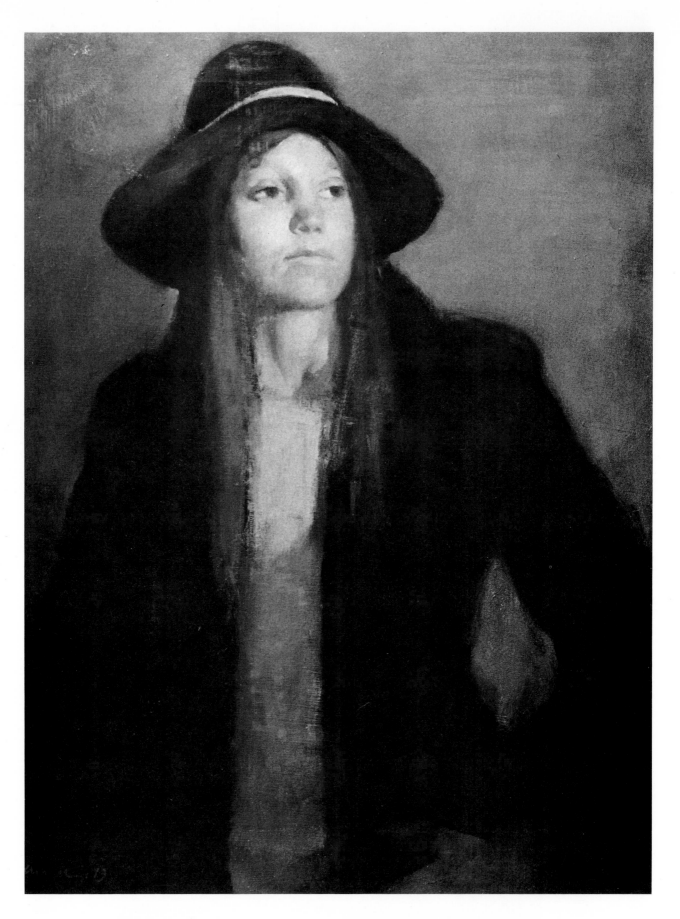

The Cowboy Hat, *1969, oil on canvas, 24″ x 20″ (61 x 51 cm), courtesy Meredith Long & Co., Houston. Worn by many young women in the late 1960s, the hat symbolized a defiance of traditional codes and the growing emergence of a new self-awareness among women. Like many of the portraits I did at this time, the painting is very sparsely rendered except for the head. The colors are all warm earth browns and siennas.*

Contents

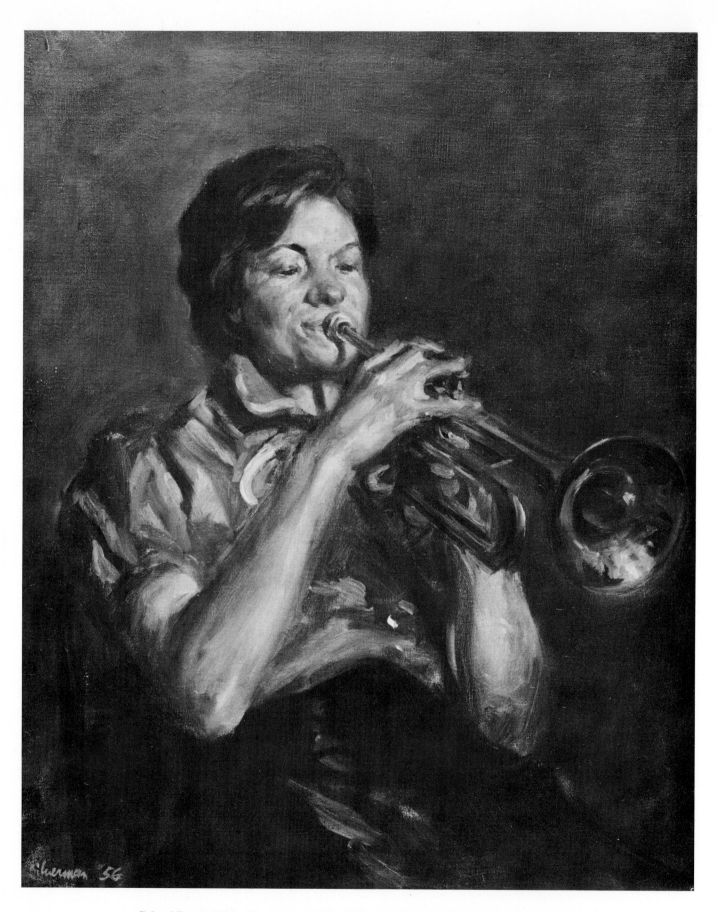

School Band, *1956, oil on canvas, 16″ x 24″ (41 x 61 cm), collection John and Dora Koch. One of my earliest paintings, this was in my first one-man show at the Davis Galleries. It's painted with loose brushstrokes that happily express the enthusiasm of the trumpet player. At the time, I took special delight in the fact that it was a girl playing—an intuitive leap to the age of the women's movement.*

Techniques

These opening chapters of the book are devoted to a history of my development as an artist and to the evolution of my views on art and Realism. These ideas have played an important part in determining the character of my work—guiding my decisions on how and what to paint, and affecting my choice of materials and techniques. As the reader will discover, I have no hard rules, no charts or color wheels, but rather a set of conceptual and emotional goals that require flexibility and adaptation in order to search out the truth in the pictorial experience. Ultimately this requires as much self-awareness as technical facility. In this sense I am forever a student, and my art is forever in the state of becoming.

Personal History

One of the questions I'm asked repeatedly is: "What kind of painting do you do?" Generally I hesitate for a moment and then almost reluctantly reply: "Realistic." In that pause, I'm aware of a flood of contradictory thoughts about realism, a flicker of defensiveness, and the difficulty of describing my work in a single word.

Before I go on to explain my special view of realism, I would like to describe some of the events and ideas that have shaped my development as an artist—to flesh out some of the reasons behind why and how I paint.

Beginnings

I was born in Brooklyn in 1928. Compared to many kids born during the Depression, I had a comfortable childhood. But by current middle class standards, my cultural life was really rather deprived. No puppet shows, children's theaters, museum tours, or marvelously illustrated children's books. Yet something *was* different for me. I could draw very well. I also had parents who recognized that painting pictures *could* be a valid substitute for the Stradivarius. I'm sure that they were also encouraged by the fact that my talents were clearly recognized by others. Special attention at school—a sense of being better at art than the other kids—made up for the fact that I was a rotten third baseman on the stickball team.

I drew and painted that special world of daydreams and fantasies that is so much a part of a child's life. My pictures were images of faraway places and exotic people—sunset landscapes, sailing ships, and ancient Roman soldiers. (Indeed, these were the characteristic elements of the Romantic paintings of the nineteenth century; years later I discovered Turner and Constable with a sense of immediate recognition.) I was fascinated by illustrations in romantic adventure stories for kids. I lay in wait lustfully for N. C. Wyeth's and Howard Pyle's books in the local library. Beset by boyhood reveries, I drew pictures to give them substance, and I attempted to draw them as realistically as possible.

My efforts were reinforced by the admiration of my peers and adults alike. And so at the age of nine, I got thirty-five cents every Saturday morning for the subway ride (and a malted) to Pratt Institute's children's classes.

I was also given my first art book at this time. It was a history of Northern European Renaissance artists like Van Eyck and Van der Weyden—strange names and forbiddingly austere paintings of people in long cloaks. I began to learn of a whole new world of great art. Other books followed. One in particular, called *Modern American Painting*, was a favorite. It was a pictorial survey of American art from the Colonial period up to the late 1930s, with marvelous full-page reproductions of Homer, Whistler, Ryder, and Sargent. I was nine or ten years old when I painted my first oil, a copy of Hopper's *Lighthouse*, from this book. But curiously enough, I had never seen an original painting, nor even the *outside* of a museum or gallery. In those days a kid from Brooklyn went to Manhattan only to see a specialist.

The World's Fair

That was all to change, however, with the arrival of the first New York World's Fair in 1939. For with it came a mammoth exhibition of the world's great masterpieces. The show was dazzling in its scope and quality, covering 400 years of Western art and including all the giants—Caravaggio, Rembrandt, Velásquez, Tintoretto, Veronese, Titian, and on and on. I wandered awestruck through the three vast pavilions. I felt a surge of excitement that was to transform me. I'd had no prior experience to prepare me for the impact of these paintings. The size and color—the *aliveness* of the work—hit me almost like a physical blow. But it was the more naturalistic painters who were especially absorbing. The paintings of Eakins, Homer, and Sargent were breathtaking. I couldn't believe that it was possible for anyone to *really* paint these pictures. Even now, I can recall the feeling: a childlike gasp, almost an unwillingness to look too long, lest it somehow be "used up."

I came away from that show forever stamped a realist. I wasn't aware then of any movements in art history or even of the concept of realism. But the paintings suddenly brought into focus all my aspirations about art. I wanted to paint the world as beautifully—and as accurately—as those great artists did. To this moment, I can say that some of that original feeling still persists—that thirsting for the world made more real through paint.

"Music and Art" High

In 1942 I entered the High School of Music and Art in Manhattan, a school filled with talented kids from all over the city. The teachers expected us to *perform* and treated us as if we were, in fact, mature artists. I became friendly with students like Harvey Dinnerstein, Daniel Schwartz, and Herbert Steinberg, all of whom were to affect my life decisively and all of whom were destined to become professional artists. They were incredibly talented and seemed full of unbounded confidence, and exotic preoccupations such as going to museums and galleries, making etchings, drawing in sketchbooks, and talking about art and politics with a kind of certitude that is only tolerable in the young. Because of this joining of art and politics, I became convinced that painting—or what I then regarded as good painting—should have a strong moral undertone that would alter the viewer's consciousness and perhaps influence social change.

As we prowled the galleries and museums in search of great art to learn from and emulate, we slowly evolved our system of values. It placed a premium on draughtsmanship—the ability to represent the world with realistic fidelity—and a necessary corrolate, social awareness. We became known as the "Soyer group" because four of the group were studying on their own with the late Moses Soyer. We were at odds with the general direction of the other students and teachers, who emphasized "creative forms," "distortion," and "expressiveness." The pressure to conform—to paint like the "moderns"—was all around us. Nevertheless, because the group was so talented and because the school was not authoritarian by any means, we achieved respect and admiration for our offbeat point of view.

My friends were enormously helpful to me as a source of support and stimulation. In particular, my drawing was very much influenced by Harvey Dinnerstein, who is still my close friend. He's a man of great feeling, an extraordinary artist, and a simply marvelous draughtsman. When we were students together at Music and Art, and in the years that followed, I frequently imitated his style and consequently learned more from him than I did from almost anyone else. I was similarly influenced by Levine, Shikler, and Schwartz, all of whom later came to be part of the realist group at the Davis Galleries.

College and the Army

My college years were spent at Columbia University, where I majored in art history, and my afternoons were spent drawing at the Art Students

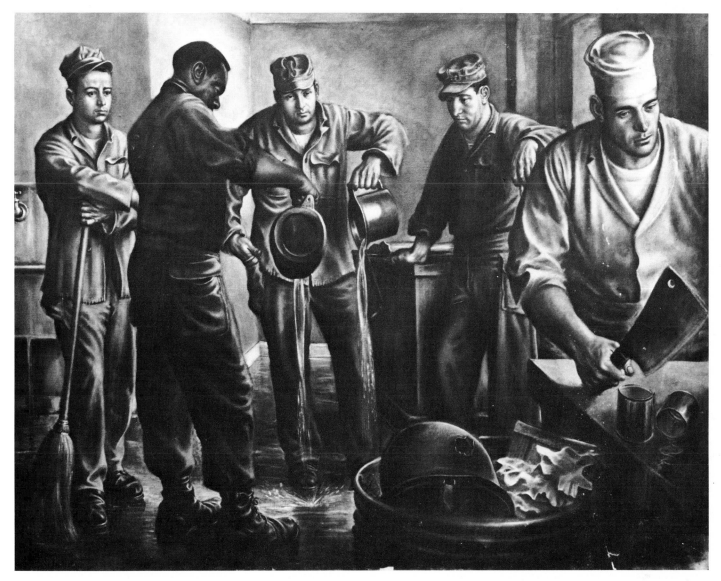

League. I studied the incredible legacy of Western art and became fascinated by the Flemish primitives of the Northern European Renaissance. I was back once more with Van Eyck and Hugo van der Goes—who painted anguish with detached, crystalline exactitude—and my own work turned into an homage to these fifteenth century sharp focus realists. I became aware of the tremendous diversity and flexibility of realism—and finally how *tame* realism had become. I began to feel that it was possible for realism to flourish once again, and I hoped to be a part of this renaissance.

When I graduated in 1949, I rented a studio on Union Square in Manhattan with Harvey Dinnerstein. It was a tough time. Suddenly I was out there in the world, cut loose from the secure moorings of school and student life. I was apprehensive about the growing political repressiveness of the Cold War, anxious about making a living, and preoccupied with sex. My paintings at this time reflected this gloomy, tense period all too

well. I remember a couple of them. The first was of a slaughterhouse, showing a large steer at the moment of execution. The other was a Goya-esque rendition of a Coney Island girlie show. Both were gray, depressed paintings, heavy with a self-conscious "message." A year and a half later Harvey and I were drafted during the Korean War.

I was discharged from the service in February 1953 and took a new studio in Brooklyn Heights. More difficult times trying to get it all together. By way of purgation—to get the Army out of my system—I painted a large, almost surrealistic picture of K P s (myself among them) absent-mindedly mopping the kitchen floor. Painstakingly done, the picture consumed six months' time, but finally it left me free to go on to other things—to living in the present.

The Davis Galleries

I was still in contact with my old friends, plus some new ones from the Tyler Art School in Philadelphia. Among them was Roy Davis, who had put aside his paint-

The KPs, 1954, oil on canvas, 42" x 54" (107 x 137 cm). Originally, the liquid being poured on the floor was blood, but I rejected this as being too blatant—and possibly repellent. The painting is done in the meticulous style that I'd adopted in the late 1940s in the spirit of the Flemish painters of the fifteenth century. The figure on the extreme left is a self-portrait. The third figure from the left is David Levine.

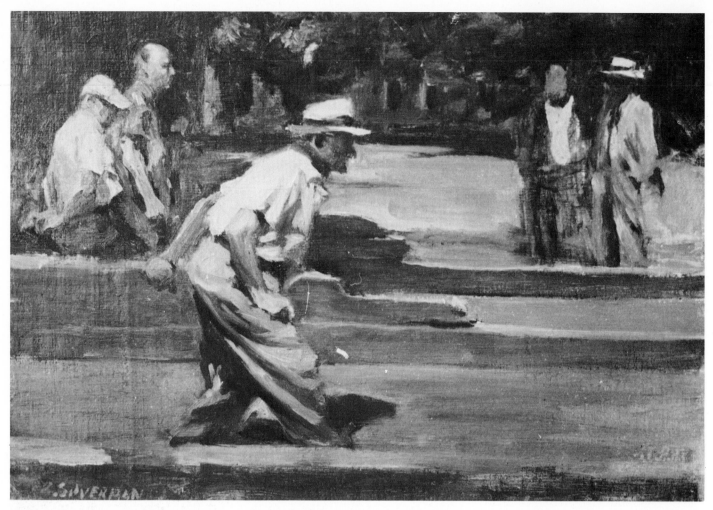

Bocce, 1955, oil on canvas glued to wood, 10″ x 14″ (25 x 36 cm), collection Mr. and Mrs. Howard Koppet. One of the paintings in my first show at Davis, I think this summarizes the spirit of the gallery's interest in the painterly, sketchlike picture.

ing to become an art dealer. Roy's gallery—then called the Davis Galleries on East 60th Street in Manhattan—was an intimate, stylish space that lent itself extremely well to small-scale, exquisitely framed art. The tone of the gallery was not unlike the contemplative quiet of a nineteenth century drawing room. Roy Davis' taste was indeed rooted in the period, seasoned with an affectionate dash of Post-Impressionist modernism. He gravitated strongly toward a painterly style in which the brushstroke was king, the kind of brushstroke you could observe in Velásquez, Manet, Renoir, or Prendergast. The artists and their dealer shared this enthusiasm.

I joined the gallery in September 1955 and found myself in a four-man show with other artists who had also recently joined the gallery. This was the beginning of another new and heady experience. The gallery artists, most of whom knew each other as friends, were all men of exceptional talent. The paintings (and later sculpture) were diverse in character—landscapes, still lifes, figure groups, portraits—and reflected a wide range of interest in contemporary life. There was a creative stir in the air. Something vital and true seemed to be taking place.

The Davis exhibitions were, in some sense, like refresher courses in art history, but with a difference. For while there were genre paintings touched by Vermeer, or landscapes that echoed Constable, or portraits that recalled Sargent or Rembrandt, they were not just simple-minded revivals of these styles. The work was steeped in affectionate debt to older art, but each artist's personal experience still animated the work, and some part of contemporary life was portrayed with freshness and vitality.

At this time, my work generally reflected the overall esthetic spirit of the gallery. My paintings were small, quiet compositions with an inordinate concern for brushstrokes. The paintings came from everyday life: the elevator operator in my studio building, a crusty-faced man whom I saw only in the pale yellow glow of a bare incandescent bulb; the young boxers in a local gym; the workers on an elevated expressway construction site in Brooklyn. The pictures also reflected the twin strains of my personality: the romantic daydreamer fused with the observer of people. "Romantic realism" is the easy catch-phrase that comes to mind, and this description often appeared in the

reviews that followed my first show. Despite the distortions created by such labels, the label was generally accurate. I can say that rather easily now, but back then, I was terribly defensive about my work—and not a little insecure.

A One-Man Show

I experienced the shock of "professionalism" in preparing for my first one-man show, which took place in 1956. It was a new kind of anxiety and one that I've never quite been able to shake. For I was suddenly required to expose myself to a kind of scrutiny that seemed terrifying. *Strangers* were going to look at my work, were going to examine it and surely see all the blunders, all the failed ideas. Of course, nothing of the kind happened. I came to realize that I'm my own severest critic. Certainly no one can approximate the artist's "inside view" of his own work—can understand his private elation and despair.

I got through the opening with a modicum of poise and with new insights. For that's the final thing that happens on the road to being a professional. Looking at the work in a new place, I saw the paintings differently. Some qualities that I had thought so strong, suddenly seemed insignificant. A beautifully rendered passage of paint, so glorious in the studio, was almost invisible on the gallery walls. Paintings that seemed to be strong and dramatic "statements" on the easel—in the protective warmth of the studio—suddenly turned pallid in the impersonal atmosphere of the exhibition.

Good things can, and usually do, come out of this kind of realization. I immediately began thinking of what my new work should look like and the changes I would make.

Documentary Art

Before I could set about on my "new" course, however, I found myself taking on another task. Two months before my 1956 show, the entire black community of Montgomery, Alabama, had launched a mass protest that came to be called the "Montgomery Boycott," the first action of its kind in the South. Harvey Dinnerstein came to me one day in late February and asked if I would like to go with him to draw the boycott. My response was immediate. We left on March 5th with his wife, Lois, who kept a written record of the experience.

We were incredibly moved by black gentleness and humanity. And our drawing skill was put to a rigorous test: to convey the dignity and strength of the blacks and to get it all down in the rush of ongoing events. This meant trying to remain "distant" enough to make an effective piece of art without losing contact with the intense feelings being generated at the moment of creation. Harvey remembers me at a black church rally, swaying and chanting to the marvelous Gospel music and my hand drawing furiously—caught between being participant and observer.

We brought back over 90 drawings of this boycott in which Martin Luther King rose to national prominence. The drawings were exhibited at the Davis Galleries the following October. Many appeared in newspapers and magazines. Some were purchased by a museum. But they never made the art magazines. Was it because they were better reportage than art? Perhaps so. But my gut feeling, twenty years later, is that they were human statements rather than political ones. And if they survive at all, it will be because they have emotional qualities that are independent of the social or historical implications of the event.

Discontent

Despite the sense of vitality and relevance surrounding the gallery and its artists, few of us could live on the sales of our art. Since 1954 I had been working part time at the *New York Post* as a graphic designer—the start of my continuing career as an illustrator—and painting nights and weekends. Yet there seemed to be time enough for everything. In 1957, the gallery group decided to do a show based on rediscovery of the Hudson River, through the eyes of a revitalized realism. We set up easels from Weehawken, New Jersey, to the Bear Mountain Bridge. *The Hudson*

Untitled Drawing, *1956, pencil on page, 10″ x 8½″ (25 x 22 cm). This appeared in the* Montgomery boycott exhibition, The Artist as Reporter, *with a quote recorded by Lois Dinnerstein: "I used my hunting money for gas this year." This was a laconic reference to the car pools organized by the black community to maintain the boycott of the segregated municipal buses.*

River Revisited was the title of a thought-provoking show in the Fall of 1957. This was the start of my interest in landscape painting and a renewed involvement in watercolor for working outdoors.

The paintings in my next show at Davis (in October 1958) were quieter, more inward, perhaps reflecting my recent marriage. There were many more interiors—people on couches gazing reflectively, perhaps even sadly, at some private vision. The reviews were equally gentle in their praise *and* in their rebuke. I wasn't happy with the show and felt the need for something different. My feelings fed directly into the discontent that slowly began to emerge within the gallery group.

Despite an ever-widening audience, critics among them, the gallery seemed confining. The artists were restive. Many felt inhibited by the smallish space that seemed wrong for large works, and they were impatient with its elegance and refinement. There seemed to be no "room" for a "bad" painting which ventured beyond the acceptably safe, small gem. And, finally, perhaps it was ambition that stirred unrest. The artists wanted to reach a bigger audience, wanted better prices and more sales. They felt that the way to get this was by critical recognition, which was not happening as quickly as they had hoped.

The discontent of the gallery artists was emerging against a background of tumultuous events in the art world. In the late 1950s, Abstract Expressionism and the New York School were reaching their peak. Magazines and newspapers featured color spreads and glamorous profiles of the new bohemians and their dynamic new art. It was the dawn of the new star system in the American art market. Sponsored by aggressive, "cool" dealers, the art market became international and the prices astronomical. Up to that point, American art had been stigmatized as either provincial or second-rate School of Paris. But the abstract painters of the New York School represented newness, power, and authenticity. The international art world took to them, enamored of their energy and decorative optimism.

For those of us at the Davis Galleries, rooted in the great art of the past, Abstract Expressionism became a galling bad joke, a grotesque distortion of genuine esthetic values. All our current frustrations were brought to the surface by this new art. The blatant obviousness of Abstract Expressionism made a mockery of our subtleties. The immediate visibility of those immense, raw canvases made us feel that much more invisible. And the "heroic" scale and graphic bombast of a Pollock or a Kline, for instance, made the quiet delicacy of our work seem more like fatigue than sensitivity.

A Realist Exhibition

All this exacerbated our feelings of neglect and impotence. We had indeed become "invisible men" in the art world. We began to meet regularly in the spring of 1960 to plan a counterattack—a large exhibition of realist art. The purpose? To announce ourselves and our point of view, as the only viable alternative to the "madness" of modernism.

There was also a secondary (and perhaps more complicated) motive that wasn't necessarily shared by all the artists: a desire to demonstrate that we were capable of a broader, more "relevant" viewpoint than was generally attached to the work seen in the gallery. If our work had once been tasteful, esthetically "correct," and polished examples of a kind of updated genre painting, now many of us wanted to show the symbolic, heroic, even provocative side of our art. We wanted to lay claim to the authenticity and importance that so many critics found in modernist painting.

Unfortunately, in our isolation—and yes, arrogance—we could find no room for any but ourselves in this show. Clearly there were many artists of stature who were painting representationally and who would have broadened the impact of the exhibition, giving it more validity as a "viable alternative" to abstraction. But we were mesmerized by our own needs and our own egos. We assumed the role of a *Salon des Refusés*, and we were out to dazzle.

After a year or more of preparation, eleven artists, all but one from the Davis group, had assembled their work for the exhibition. The eleven artists were Harvey Dinnerstein, Sheldon Fink, Julian Fishburne, Stuart Kaufman, David Levine, Seymour Remenick, Daniel Schwartz, Aaron Shikler, Herbert Steinberg, Robert White, and myself. *A Realist View* opened at the National Arts Club on May 1, 1961. The exhibition space was large, woodpaneled, and, as it turned out, rather depressing. Over 100 paintings, drawings, and sculptures succumbed to the deadly environment. Despite a large, well-attended opening, and even a full page negative review by Emily Genauer in the old *New York Herald Tribune*—and despite the presence of some very good paintings—the show proved to be a failure. The exhibition did not attract any real attention from the critics. If certain paintings were weak, this weakness was underscored by the lack of diversity—the absence of other good artists outside the group—and the consequent failure to show the varied possibilities of realism. If anything, we succeeded only in confusing our most ardent admirers. We wanted the show to be dramatic and compelling. It was not.

Furthermore, the credo put forth in the catalog failed to convince anyone, or even to illuminate our point of view. The text was esoteric, rhetorical, and defensive. We seemed to be fighting a private, rearguard battle against the epithets so often used by avant-garde critics, such as "slavish imitation of reality" or "mere illustration." We tried to prove that we were different from—and better than—the "old fashioned academicians."

The words in the catalog and the paintings on exhibit didn't quite match. We all believed that the art would exemplify the text—that it would be exciting and multifaceted—but we had dined too long at the same table. We had become a group, as parochial as any other group.

More Realist Exhibitions

Nevertheless, the exhibition may have had some effect. Perhaps it did give some dealers the courage to announce their own commitment to the realist tradition.

Less than a year after *A Realist View*—in April 1962—Hirschl and Adler Galleries in New York put on a giant, two-part group show called *The Continuing Tradition of Realism in American Art*. Ninety artists were represented in this roundup, including all the people at Davis and many who should have been in *A Realist View*. These included artists who grew up in the 1930s and whose work we'd admired: men like Raphael and Moses Soyer, Jack Levine, Andrew Wyeth, John Koch, Edwin Dickinson, Edward Hopper, and Walter Stuempfig. It was a show without a manifesto, and it was as good a show as any such survey could be.

Two years later, another realist exhibition—a little less ambitious in size—was organized by John Phelps Dodge of the Albany Institute of History and Art. I was included in this show, along with Dan Schwartz. The work was similarly diverse and ran the full gamut of styles

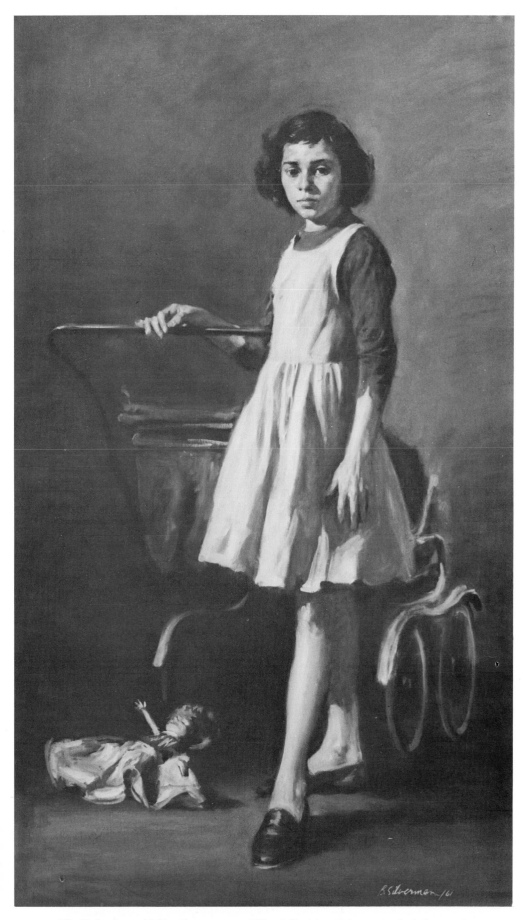

__The Babysitter,__ 1961, oil on canvas, 32″ x 54″ (81 x 137 cm). Included in my first show at the Kenmore Galleries, the painting was a portrait of a girl who lived across the street from me in Brooklyn. She always seemed beset by family chores and much older than her eleven years. The picture owes a strong debt to Velásquez.

that could possibly be embraced by the name "realist." The catalog of *Contemporary American Realism* contained a long text that said many of the same things that we had put forth in our own catalog, but the language was cool, objective, and nondefensive.

The writer spoke of "a loss of confidence and interest in Man and his environment, which had been the principal subjects of realism for five hundred years . . ." and then pointed out: "The creative realist of today has a further hurdle in that a large part of the viewing public does not often take the trouble to look beyond the surface of familiar shapes into the artist's purpose for using those shapes. . . . The fault lies not entirely with the public, for they have been conditioned to look superficially at paintings as a result of photography on the one hand, and, on the other, because the majority of so-called realists of the past century were without a deeper purpose than the copying of the more obvious and sentimental clichés of the visible world. Most realism became tired, shallow, trite, and meaningless, and hence academic. It has taken the challenge, leadership, and now almost universal monopoly of abstract painting to demonstrate this and hence purify and revitalize realism . . . and now today, absurd as it may seem, there are a number of people who refuse to consider a painting done in the realist mode as art—or at least as a valid form of modern art."

There were other exhibitions as well, like the one now presented annually by the San Diego Arts Festival, called *Twentieth Century Realists.* In addition, several new galleries opened in New York and devoted themselves to showing the work of realists, like the Forum Gallery and Robert Schoelkopf.

There were subtle signs of change, but at the time of the National Arts Club disaster, we could not see them. Whatever the true merits of *A Realist View*, the disappointment deeply affected many of the Davis artists. They felt that there was nothing more to be gained from this group identity. Cloistered and inbred, the group had fostered a defensive insularity which inhibited change and, to some degree, stifled originality. And so, one by one, almost all of the artists left to join new galleries over the course of the next few years.

Now looking back at *A Realist View*, I feel that there *were* many good paintings in the show, but they had a terribly unrealistic burden to carry—the dream that they could alter the course of art

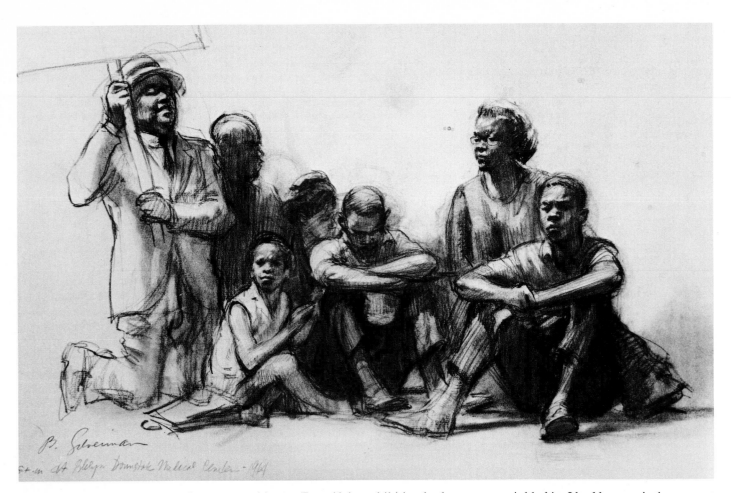

Protest in Brooklyn, 1964, pencil on Arches laid paper, 11" x 15" (28 x 38 cm). *This drawing was a combination of several different sketches of single figures which I'd done at the hospital site. Another like it is in the collection of the Philadelphia Museum of Art.*

history. Even if the exhibition had contained *great* paintings, I suspect that the critics would have snubbed it anyhow. Its time had not yet come.

The Kenmore Galleries
I had my final one-man show at Davis in January 1962. Composed entirely of landscapes, it turned out to be my most successful effort there, ironically enough. But by the end of 1964, the gallery was dealing primarily in nineteenth-century English and American art.

Meanwhile, in the spring of 1963, I had been approached by the Kenmore Galleries in Philadelphia· and had begun to send them work that still remained unsold at Davis. Kenmore was a new gallery run by a man who had very little experience with art. Harry Kulkowitz was nonetheless enthusiastic and intuitive about good painting. I decided to have a show there with almost all my new work. The results were heartening. The paintings were larger, and I felt that they were more accomplished than those in any previous exhibition. The imagery and color were stronger, too. The show was well received, and I began to feel more optimistic about my art.

Most of the paintings in the show were figures, with a few landscapes

sprinkled in. I had been painting a great deal from the rooftops of Park Slope in Brooklyn, as well as more exotic vistas on a second trip to Europe in the summer of 1962. But I still felt most strongly about painting people. I "covered" a black protest at the construction site of a new wing of Downstate Medical Center in Brooklyn. Standing there amidst the chanting picketers, I drew the frantic comings and goings of the police and the push of the crowds. It was Montgomery all over again. Over the next four years, I would also draw the civil rights and antiwar demonstrations that took place throughout the 1960s. Some of the drawings appeared in *New York* magazine. One was purchased by the Philadelphia Museum of Art. And many were included in a drawing and watercolor show at FAR Galleries in New York in May 1970.

I took on other themes as well: burlesque performers, garment workers, the racetrack. In the summer of 1965, I spent three months drawing and painting in Rome. A few months after my return, *Esquire* magazine commissioned me to paint and draw in the Far East, a whirlwind trip that covered nine countries in a month. Eight months later, I was off again to draw the historic landscape and architecture of France for the French National Tourist Bureau.

This was all capped by a second one-man show at Kenmore in 1967. The exhibit brought new patrons. Plans were made to publish a portfolio of my drawings, which appeared the following year with similar portfolios by Harvey Dinnerstein and Daniel Schwartz, who had since begun to exhibit at Kenmore. I won some prizes at the National Academy of Design, fell in love and remarried (Claire and I were married in June 1969), spent a summer in Italy, began to sculpt, and discovered a renewed interest in watercolor.

The Present
I continued to exhibit at Kenmore (until it closed in 1975), as well as at the FAR Gallery in New York and the Harbor Gallery in Cold Stream Harbor, Long Island. And we started a family in 1972. My work began to draw on experiences common to all of us: many of the paintings in my exhibit at FAR in 1975 were images of my family.

The last few years have been a time of honing and refining my work. I've looked more toward simplifying and "abstracting" my paintings, aiming for greater economy of means, so that the statement in paint becomes stronger, more expressive. It's hard work and gets more difficult with each new picture.

And what of the crusade for realism? For me, the days of argument and competing ideologies are over. No more defensiveness or belligerent propagandizing. I'm content to let the art speak for itself. Besides, in the years since *A Realist View*, the art world has become more receptive, at last. A whole new generation of young people has sprung up, out of nowhere it seems, to "rediscover" realism by themselves. More and more of the audiences at my exhibitions are these young people, many of them art students, who peer intently, ask searching questions, and seem to know instinctively what I'm after.

Freed from the small tyrannies of a group or a "movement," I'm able to be myself. I'm as committed to realism as I ever was in those days of the Davis Gallery and the group. But the need to argue has largely disappeared. I'm a realist simply because I cannot help it. It's my native language. Any other language, no matter how "modern" or skillfully learned, would seem false.

Courbet said it perfectly in his *Realist Manifesto*: "I want to translate the customs, the ideas, the appearance of my epoch according to my own estimation; to be not only a painter, but a man as well."

Painting People
As an artist and as a human being, my choice of what to paint—and how to paint it—grows out of a variety of creative needs. One of these needs is clearly autobiographical—to tell the story of my feelings and thoughts about the world. And so I paint people: people alone or in groups, active and passive.

My subjects are usually the people I encounter or observe in my everyday life. I've always been particularly interested in drawing or painting a single figure—portraits really—and these make up a large proportion of my work. I think I'm especially drawn to the portrait because of its psychological and symbolic possibilities. I also paint people in groups, usually selecting some activity that reveals something significant about their lives, though the activity itself may seem uneventful.

While I try to depict the observable world with a great deal of fidelity, I'm really not that "objective." Although my models are real people who have their own independent existence, I know that my paintings transform them into "personnae"—actors in the play of my private feelings, perceptions, and reveries. Am I painting them or me? Both, of course. For in this shadow world between the objective and the subjective, I find the perfect arena for self-expression and self-discovery.

Recurring Themes
I'm fond of incongruities and anomalies. Thus, I often paint human interactions that seem commonplace but are somehow beset by internal tension. I often paint old and young people together, or people in a group situation that usually calls for community or "togetherness," although the painting shows them to be apart, absorbed by some private contemplation or reverie.

Another paradox: I often don't know exactly *why* I'm drawn to a particular subject. Perhaps because my feelings are, in fact, never quite resolved, I wind up retelling the same "story," but with a different "ending." Thus, there are recurrent themes that I've painted again and again for more than 20 years, though I have no satisfactory explanation for the original interest. For example, I've painted pictures of women ironing. On the surface, it seems to be a rather banal, even unpleasant, subject. Originally, the subject was my mother at the ironing board. Then the subject became our housekeeper. Soon I was painting women in a hand laundry, both single figures and groups. Some years went by and in another country,

Italy, I found the image still compelling and painted it again.

There have been other recurring themes as well. These have included pictures of people (usually older men or women) seated in restaurants or cafes, as well as many paintings of men at work. The men-at-work theme is closely related to the ironing series, of course, but I think the meaning of the two is quite different.

And lastly, I am attracted by contradiction. I look for it in the faces of young people whose stylishness and "cool" often masks anxiety and withdrawal; in the image of the unskilled worker menaced by twentieth-century technology; in the blank look of the Go-Go dancer as her body gyrates in simulated passion.

In summary, I can almost say that the subject matter picks me. It touches some chord in the complex nature of my conscious and unconscious life which stirs me to paint it. The desire may simply come about because it "looks interesting." Which is to say that the image has a compelling quality that defies rational explanation.

The fact is that I'm still painting these subjects to this day, and others as well—all with a long history. Whatever the explanation for this interest, I don't think it's really important. What does matter is whether the art I produce is affecting. Does it make contact with something important in the viewer's experience? Does it stir his feelings in a way that leads to new awareness or fresh insight?

Reprise
This brief look backward at the significant events of my life as an artist has brought something home to me with great clarity. I feel now that my association with the artists who centered around the Davis Galleries was the single most decisive force in the development of my art. It was the critical factor in shaping my painterly sensibilities and sharpening my esthetic viewpoint. The group (somehow the word "group" now seems crabby and ill-fitting) was a far greater experience than the history of the Davis Galleries or the ill-fated *Realist View* exhibition has thus far suggested. The central reality of the group was the warmth of its friendships and the excitement of its intellectual and artistic ferment. The talented, sensitive, and ambitious young men who came together for that relatively brief moment provided a marvelously rich environment for a young artist. They provided encouragement in moments of despair; they were available for criticism that

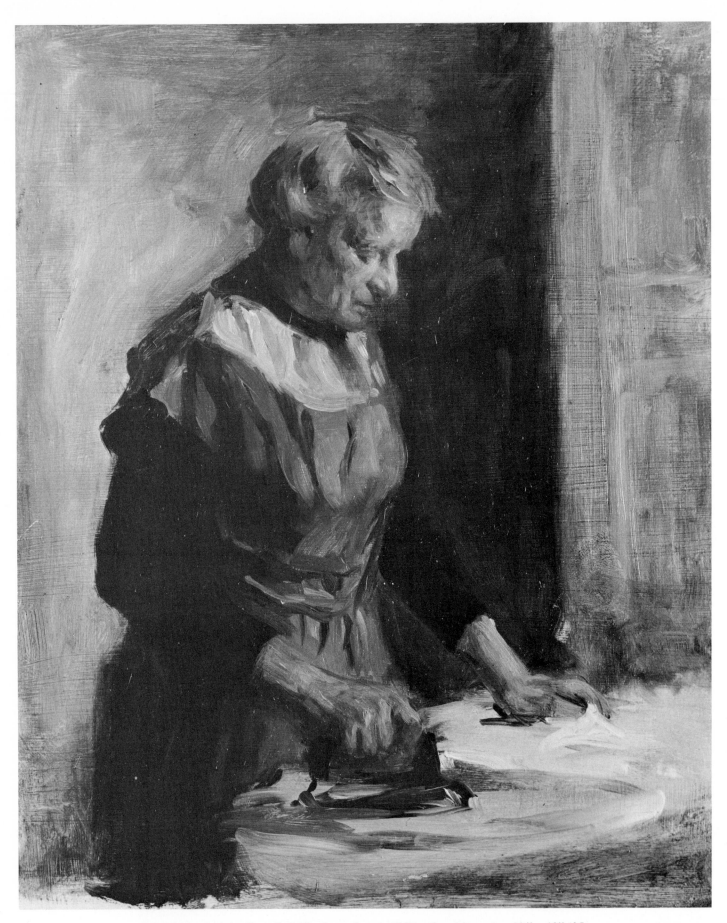

My Mother (originally called The Laundress), *1955, oil on Masonite, 10″ x 12″ (25 x 30 cm). The picture was painted in my then typical colors of umber, gray, and Naples yellow. The dark passage just surrounding the right side of the figure is all in translucent glazes, as is the dark side of the head. The picture was included in my first exhibition at the Davis Galleries in 1956.*

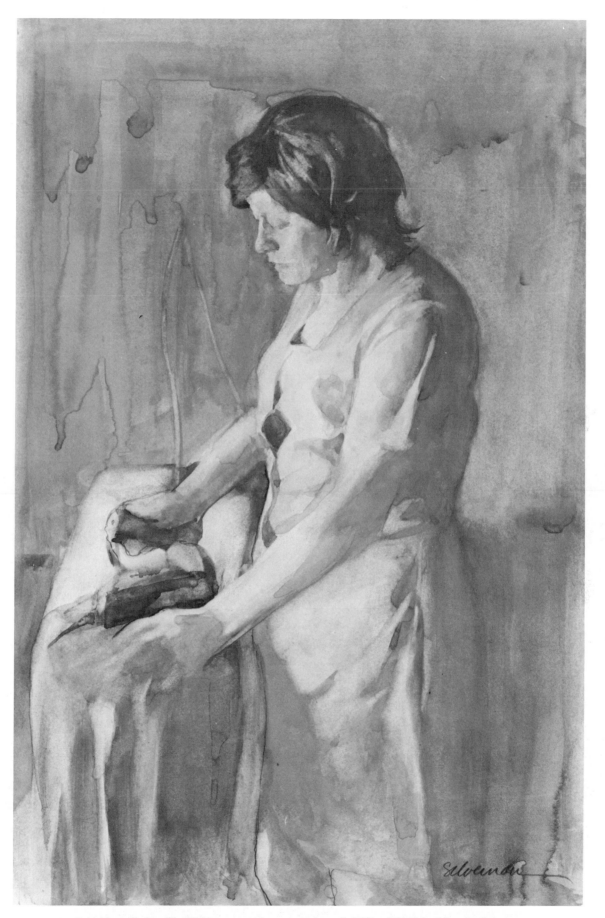

Laundress in Profile, *1973, watercolor on rag board, 9½″ x 15″ (24 x 38 cm), Courtesy FAR Gallery. This painting was part of a series of pictures of Italian laundry workers, but with a startling similarity to the painting of my mother done almost twenty years before—a painting I'd all but forgotten.*

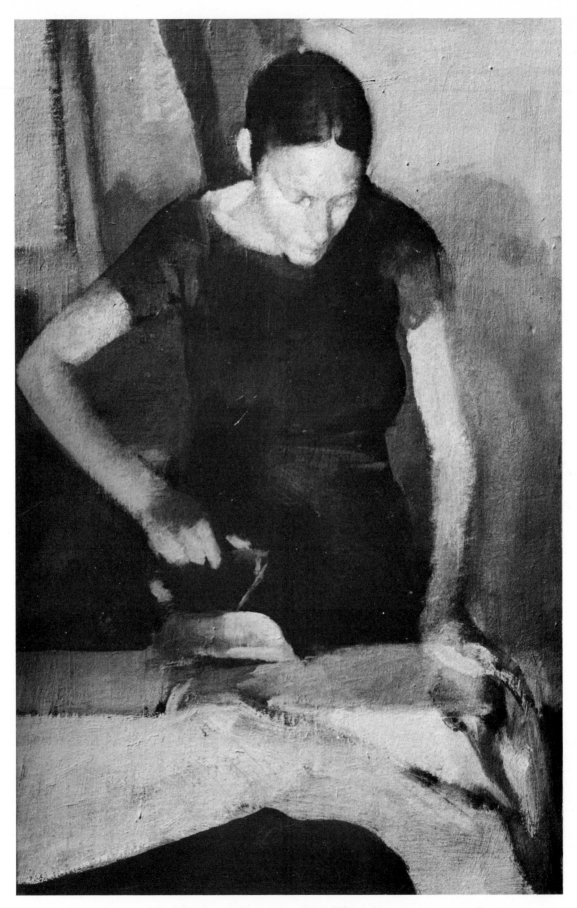

The Laundress *(the study for this is on page 109), 1974, oil on canvas mounted on wood, 7" x 11" (18 x 28 cm). This was a small-scale picture which was delightful to work on because the paint behaved so well on this surface; I could arrive at just the desired amount of detail by working in successive stages without losing control of the buildup of paint. The colors are all in the cool range, with the exception of a dark red cloth just behind the girl's left ear.*

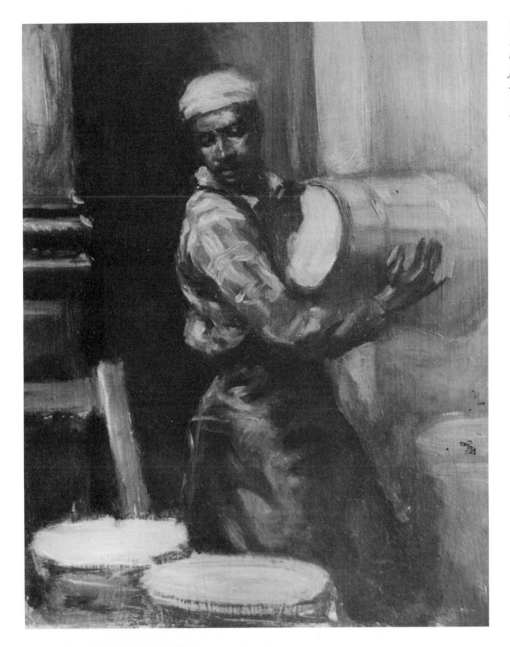

Washington Street Market, *1956, oil on Masonite, 9″ x 12″ (23 x 30 cm), private collection. This small painting was done from a photograph and was intended as a study for a large painting of the market. There's a watercolor of the same theme on page 39.*

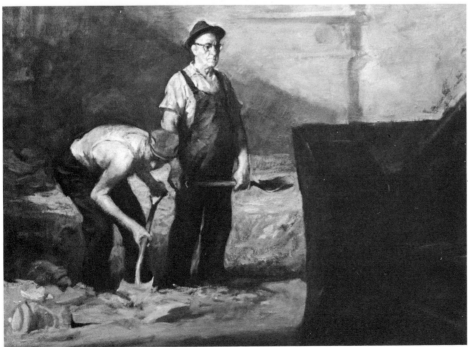

The Machine, *1959, oil on canvas, 44″ x 60″ (112 x 152 cm). This was the last of a group of pictures centering around the laborer. It was never shown in any exhibition, though for many years it was at the Kenmore Galleries in Philadelphia. It is a "difficult" picture by commercial standards, difficult to sell, that is, because of its scale and its rather somber feeling; but I think it has survived rather well.*

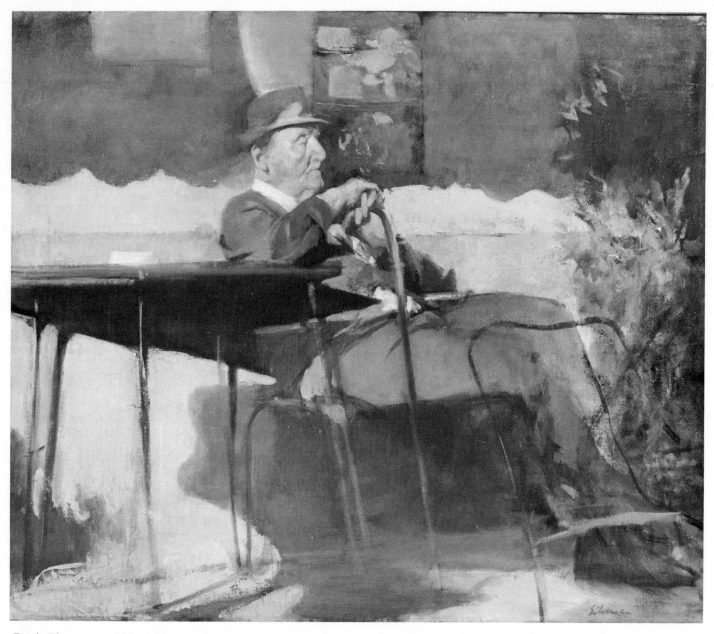

Bar in Pietrasanta, 1974, oil on canvas, 20" x 25" (51 x 64 cm), courtesy FAR Gallery. This painting is all warm colors: intense yellow ochres on the wall, the cast shadow of the awning in burnt sienna, the old man's clothing in tans and umbers. The serenity of his pose is heightened by this slumbrous light. He seemed dignified and composed until I realized that he was quite drunk on wine.

Young Man, (opposite page) 1974, watercolor on clay-coated paper, 13½" x 10" (34 x 25 cm), courtesy FAR Gallery. The model seemed very gentle and modest, so the painting surprised me when I made his expression so severe, especially since the colors are all soft and muted.

was sympathetic, though sharp; and their paintings were a competitive spur to my own efforts. The group was my home in an otherwise indifferent art world.

If the group sometimes appeared too homogeneous or restrictive, it *was* quite heterogeneous on the subject of what constituted good painting. We were frequently moved to examine the basic assumptions about our art and to question the values of the contemporary art world. This led us to search for the answers to our questions in the art of the past, to discover what made it so powerful and so enduring—not just *how* it was painted, but the secret of how it *communicated.* How, for example, did Rembrandt's impastos add up to such a moving portrayal of the human spirit? How did Velásquez paint those rich royal garments so effortlessly—and at the same time leave the royal sitter so naked? What made those mythical

prophets and remote kings appear so real and, yes, so close? Why was Sargent often a powerful portraitist despite the flamboyant *stylishness* of his characterization. And why was Eakins so grittily unpopular, yet continually fascinating?

We wrestled with and argued about these and many more questions in the corridors and galleries of the Metropolitan Museum and the Frick Collection. In the end, all this helped me to forge a point-of-view that was to demand more of a painting than just lovely paint surfaces or beautiful drawing or glowing colors. Through this critical exchange, my taste in art—already wary of things too pretty or idealized—was both clarified and reenforced. It helped me in my painting as well. I scoured the great collections to find solutions to problems that hung on my studio wall: how to solve a background here or a spatial problem there. Some of the "answers" worked; others did not. Some I

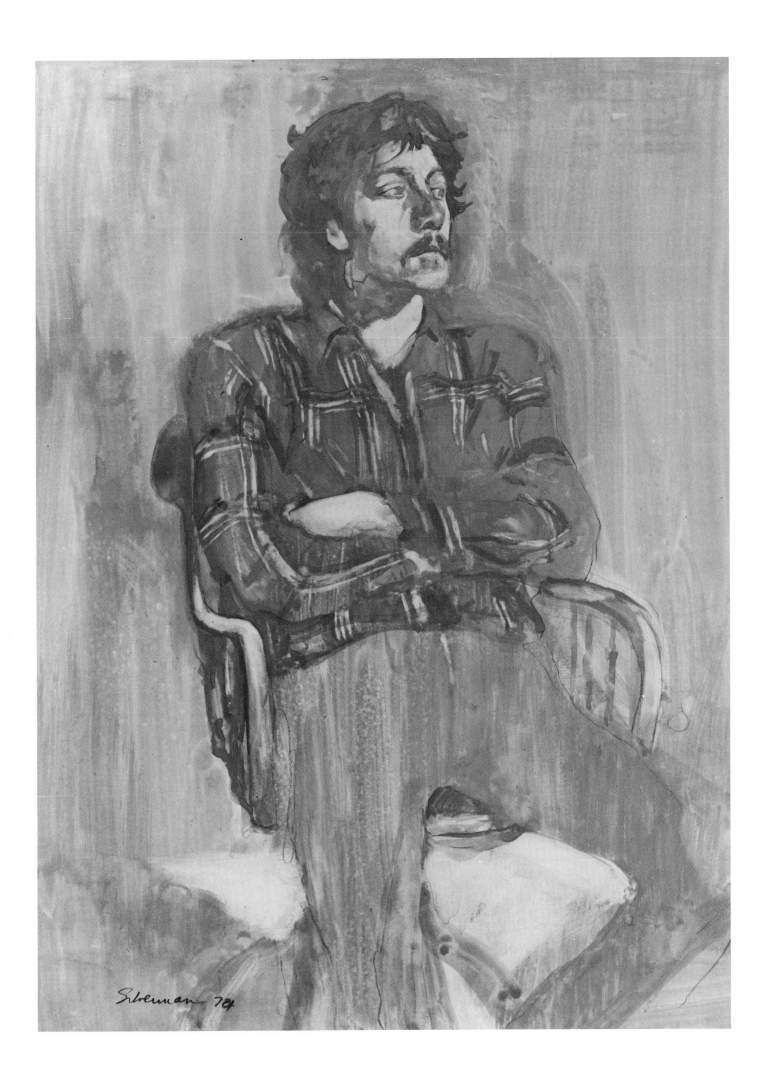

Silverman 7&4

still use; many have been discarded.

Searching through some papers when I began to write this book, I came across a small diary which I'd kept on my second trip to Europe in 1962. The following entry from it effectively summarizes the character of my thinking at that time—and to some extent to the present moment.

"Madrid, Aug. 4. Four days in the Prado looking at these great paintings have given me an urgent desire to start working again. I've become impressed as almost never before with the scope and power of these masterpieces . . . with the sense of immediate enjoyment they give. First is the pure picture-making quality—the image of some grand event or some heroic figure (a nobleman perhaps, as with Titian)—to attract the eye. Then a host of sensations and feelings slowly unfolds to wrest the imagination from its conventional preoccupations. And finally, an awareness of their powerful, yet so apparently easy rendering of these rich visions. To see a room full of Titian, Van Dyck, and Velásquez is to become engorged with a sense of breathtaking possibilities, and a new consciousness of one's humanity."

There's a kind of mystery about all these things—the people you meet and the events that color your decisions. Perhaps I would have become the kind of artist I am anyway, despite the group. Certainly my ideas have mellowed— even changed dramatically—with the years and with new experiences. But the spirit that first attracted me to the group remains alive. The kid who stood marveling at the masterpieces at the New York World's Fair, who secretly vowed to paint as well as those extraordinary artists, still flourishes within me, still guides my search for a more humane, more compelling art.

The Studio

For many years I worked in studios that were actually the living rooms of large, old-fashioned New York apartments. In those days, the thought of a skylight, with its unwavering, cool north light, seemed as remote and exotic as a daydream of tropical islands and soft music. That ideal studio, with its skylight, somehow symbolized spaciousness, airiness, and freedom from clutter. I've never quite reached that ideal. Though my current studio *has* a skylight, this is no longer the kind of light I prefer.

Light

The light in my studio varies considerably during the day—and from day to day. The skylight gives me a steady light, but the illumination level is low; this is especially true on sunny days, surprisingly enough. There's actually more light on cloudy days with *high* clouds that bounce a lot of light around. Blue skies are relatively dark and *absorb* light.

I often use the skylight when I'm painting by myself, but I rarely pose the model in it. In the past, I had to settle for ordinary room windows to paint by daylight; I've since discovered that this "compromise" was, in fact, the kind of light I *preferred* when someone was posing. It's really more natural—and in some cases more dramatic—than the soft, diffused illumination of the overhead skylight. And because the light in my studio is variable, I usually pick a time of the day when, by observation, I've determined that the light is most constant. I then have my models pose at that time only, most often by window light.

I also find that I have a bias about skylights: an uncomfortable recall of the studios of uninspired academic artists and the predictable look that such light produced in their paintings—especially the portraits.

I've mixed artificial and natural light for some situations where it seemed appropriate, such as trying to recreate a theatrical environment or perhaps an interior at night. I've started paintings in daylight and finished them under incandescent light. However, recent developments in fluorescent lighting have made it possible to simulate daylight rather well, so that switching from natural to artificial light doesn't present that much of a problem anymore.

The worst lighting problem for me has always been the transition from studio to exhibition space. Galleries are often lit by ghastly incandescent spotlights or equally troublesome fluorescents. Subtle passages of paint and certain warm colors turn raw and ill-fitting in this light and often make the picture painful to look at.

It's a well-known story that Turner used to finish his paintings in the exhibition halls of London's Royal Academy before the exhibition opened. Although this was sometimes reported as a kind of grandstand gesture, it was probably Turner's way of adapting the picture to the light in the gallery. Turner was apparently determined to overcome the problem by painting his picture in the light under which it would be viewed. Admittedly a dramatic solution, but shrewd nevertheless; his work *did* literally "outshine" that of many of his contemporaries.

Organizing the Clutter

My studio is large and relatively spacious, but I always manage to fill it with a variety of things, ranging from accumulated pictures to "valuable" equipment of all kinds—even power tools that I use maybe once or twice a year. I've never worked out an "ideal" method of organizing my studio, but I don't think that physical surroundings necessarily produce the best art. The paintings I once produced in cramped, sometimes dimly lit apartments, years ago, had their faults; but these faults had nothing to do with a deficiency of space or lighting.

I'm constantly involved with reorganizations: finding new cabinet space for storing paper or allocating new drawers for sketches, prints, and watercolors. Despite my best efforts, the work and the equipment always seem one jump ahead of me. The clutter usually accumulates most ferociously when I'm working for a show. Canvases spill out of the racks and onto the walls, or they just lean against a table. And all sorts of reference material starts piling up on desk tops, chairs, and whatever else will hold the stuff.

Nevertheless there *is* some method in all this apparent madness. I have racks for storing old or unresolved paintings; two large and invaluable blueprint tables for paper supplies, drawings, pastels, and prints; a variety of drawers for small watercolors, drawings, and photographs. A large oak easel is complemented by three smaller portable easel boxes, which are sometimes left open but are generally stored in the unused fireplace of our Manhattan brownstone. My studio is on the top floor, within earshot of the family just below.

I use a variety of tabletops for working on watercolors, and the small, portable easel for pastels. I generally sit while I'm doing pastels, since this feels a lot like drawing; I stand while I'm painting in oil; and I do a little of both when I use watercolors.

I generally keep a variety of things out of the racks and on the wall—paintings and drawings in all media, both current and older work. This serves to warm up the place, is interesting to visitors and students who come to paint twice a week, and serves as a kind of road map for me, suggesting where I've come from, and perhaps where I might be heading.

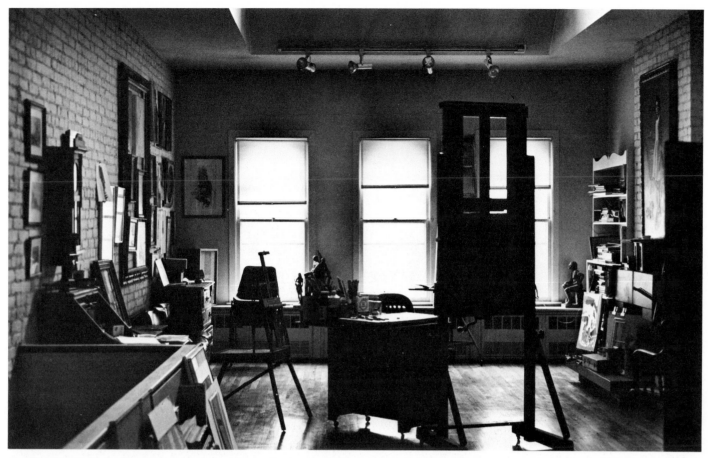

Studio, North End. *Shows paintings on the wall, the skylight, windows, and the beginnings of clutter all around.*

Studio, South End. *Shows blueprint cabinets, part of the storage racks, and additional drawing tables and reference books.*

Studios and Personalities

The artist's studio is a very clear expression of his temperament, personality, and working habits, and often shows up in the paintings themselves. I remember Raphael Soyer's studio from many years ago, with its gray, small-business-colored walls, and a kind of soft light that cast the models' eye sockets in shadow. These were qualities that Soyer used in his work—or at least they found their way into his paintings at that time.

Other artist friends exhibit a similar harmony of place and person, though there isn't *always* such a correlation. Harvey Dinnerstein's studios have always been strewn with a dizzying collection of canvases, drawings, pastels, notes, and clippings, with no discernible order. Yet his work is clear—even austere—in its sense of careful control of forms and space.

I'm not sure what qualities might be culled from my studio. But, like everyone's studio, it's a personal space and probably displays all sorts of quirks that *aren't* essential to the production of paintings. Above all, I feel now that this space functions as a kind of arena—a battleground maybe—where a painting is finally wrested out of the thousand possibilities and conflicts of the creative process.

Tools and Techniques

I'd like to make some general observations about painting materials and techniques before I begin to elaborate on each of the three major media I use.

Technique and Expression

By now the reader has gathered that I'm much more interested in the expressive character of a work of art than in technique. In all honesty, I must add that I'm sometimes distracted by some painter's extraordinary display of technical skill, either in his drawing or in his handling of paint. I do love to see that kind of thing, just for its own sake. But the real test of a work of art is its ability to move your emotions long after you've stopped looking at it.

The methods I choose for any given painting are arrived at by a combination of factors—by what I'm painting, by the size, and by my general feeling about the subject matter before I start. The methods may change if I find them

out of character with the subject or with my response to that subject, and I'll change the method for purely expressive reasons. I don't use "techniques"—that is, some kind of gimmick like a heavy impasto or a spatter or a drip—because it just looks interesting or spontaneous. I know how the look of the paint itself can heighten the expressive potential of a painting, but that sort of thing must be an integral part of the painted image, not an effect for its own sake. What I'm saying here is that the means and the content are bonded together, just as the timbre and intonation of your voice are tied to the words you speak.

The "Right" Medium

Nevertheless I think it's important to know that each medium has intrinsic qualities that often provide other levels of enjoyment in a painting. For example, the watercolors of Turner and Sargent exploit the translucent elegance of a simple wash to depict a mist-drenched lake or a sunlit Venetian facade. Rembrandt's impastos and glazes give both weight and spirituality to sumptuous garments and luminous portraits. And though I'm wary of our twentieth-century preoccupation with "pure painting," I think that the artist's personal touch—the feel he has for the materials—is essential in furthering the emotional qualities of the art.

While each medium has its own technical "rules" and its own special impact, they also *share* important characteristics. We can thin oil paint with turpentine so that oil can be used like watercolor, exploiting the translucency and freedom of a wash of color. Pastels needn't reveal every stroke, but can be worked to an extraordinarily smooth finish, very much like oil. (Look at the work of the early eighteenth-century French pastelists Latour and Perroneau for dramatic examples of this.) And watercolors can be used with opaque whites to move closer to the qualities exhibited by oils.

My choice of the "right" medium for a given painting is guided largely by training and habit, though I suspect a kind of painter's instinct plays an important role as well. Some pictures literally "speak" to me as an oil or a pastel or whatever. Then, again, I sometimes visualize a painting solely in terms of the desired paint quality or brushstrokes alone. This may sound like putting the cart before the horse, but I think many artists paint the picture in their heads before they get anything down on paper.

Of course, many decisions are often dictated by the *size* of the intended picture. For example, an eight-foot painting isn't going to be very manageable in watercolor (though it's certainly not impossible), and this would be stretching the limits of the medium.

Finally, I sometimes go *against* habit and instinct in order to open up fresh avenues of thinking. Thus, I've often used watercolors in place of, say, oils, precisely *because* of the limitations of watercolor; I'm forced to find different solutions to my rendering problems with interesting and satisfying results.

In the long run, oil, pastel, and watercolor are all just instruments whose potentials and limits I keep rediscovering. As my concept of painting changes—as I've begun to move toward more economy of means, more simplified forms—I make new demands on each of the three painting media. One's painting doesn't change completely, of course, but enough to produce fresh challenges and constant reassessments.

Oil: Materials and Methods

When I was nine, one of my relatives gave me my first set of oil paints. In my innocence, I began to use them without a moment's hesitation, without instruction, and with no feeling that they were in any way special. Over the ensuing years I painted with them quite frequently, usually making copies of paintings out of my favorite (and only) book of reproductions. It was, in fact, a great way to learn, though at the time I knew nothing of the nineteenth century tradition of copying great names in the museums.

Schooling did me in. The more I began to learn about oil, the more problematic it became. By the time I got out of school, I was a very serious student of techniques, brushstrokes, and painting materials. Too much so, perhaps. I continued to be absorbed by these matters, studying and then applying Renaissance glazing methods; painting in grisaille; using scumbles and impastos in the manner of the Dutch school; and settling finally into the *alla prima* methods so dear to the Munich school. All this led to some anxiety about the "specialness" of oils and combined with my

soul-searching about realism to produce more problems than I care to think of.

In recent years my anxieties have lessened considerably, and I'm closer in spirit to those balmy days of my painting infancy. I feel now that lovely paint surfaces and juicy brushstrokes will pretty much take care of themselves: trying to get the image and the emotion right will generally produce an interesting paint surface.

Palette Layout and Colors

I'm not an orderly worker, so my painting table—a small Victorian chest of drawers with a larger piece of wood attached for more table surface—is often a mess. The drawers were supposed to be used for the tubes of paint, but, in the course of painting, I usually leave the tubes out permanently.

Until quite recently, I'd been using a classic round palette with a hand grip, so that I could stand and work, moving back and forth as needed. I also liked the feel of mixing paint on wood. But, for some reason, I used it this way on too few occasions. So I switched to a Formica-covered piece of plywood, which rests on my table and gives me a larger mixing surface and an easier cleanup.

The colors are laid out from warm to cool, with black at one end and white at the other. But, here again, I'm not consistent: during the stress of working, I squeeze out color wherever there's room. I use all the primary colors: two blues—a "hot" Prussian and a "cool" ultramarine; two greens, following the same pattern—Hooker's and chromium oxide; and two reds—alizarin crimson and vermilion. I also use a rich assortment of earth colors: yellow ochre, burnt ochre, sepia, raw and burnt umber, and raw and burnt sienna. The white is almost always flake white because it has a pastier consistency and the greatest opacity. I used to buy only European-made paints out of some ancient prejudice that they were better made and more permanent. This isn't true today, if it ever was, so now I'm buying domestic brands as well.

Brushes

The paint table contains a wide assortment of brushes, both softhairs (sable if possible) and bristles. Roughly, they fall into two main groups: large flat bristles and smaller round sables, which are often pointed like watercolor brushes. I use small flat brushes (both sable and bristle) mostly for smaller paintings on panels or for rendering small forms. The bristles are "brights"

Old Palette. *Here's my old paint table with a wooden palette. I periodically had to take off all the accumulated dried paint with paint remover, since these spots would cake up, grow increasingly larger, and ultimately reduce the usable mixing area to a small, oblong space in the center of the palette.*

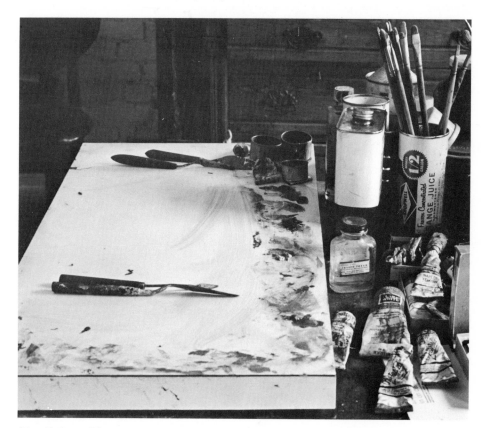

New Palette. *This is my current paint table with a formica palette. The relative disorder is about the same, except that I've added a new top to the Victorian washstand (which is the paint table), and I can now accommodate a larger palette and more tubes of paint.*

27

Bobby, *1975, oil on canvas, 18″ x 28″ (46 x 71 cm), courtesy FAR Gallery. This is an example of my more recent painting in which I chose a heavily grained canvas to provide an unexpected "grit" to an image that otherwise might yield to a conventional prettiness. I used a palette knife extensively throughout work on this surface; this can be seen most clearly in the upper right background and on the child's potty.*

or the more curved and softer "filberts."

I have no special tastes in brushes and make only a few demands—which are getting more difficult to satisfy: that the brushes hold their shape; that they don't shed; and that they're tough enough to last through occasional scrubbings on fairly rough surfaces.

Recently I've begun to use a painting knife with increasing frequency. Not for finished rendering, but rather to lay in a large area of canvas or for certain forms in a figure where I want a chunky buildup of pigment. Sometimes I'll glaze over these knife strokes or paint over them with other colors. I like the knife because it seems to get cleaner, more intense colors on the canvas than the traditional brush.

Solvents, Thinners, and Other Vehicles
I was almost weaned on turpentine. It was the first cleaning agent, paint thinner, and medium I used, and it seemed to be sufficient. But it really isn't, and should be used sparingly. Chemically, too much turpentine tends to destroy the linseed oil that binds the pigments and thus leads to aging problems.

I've worked with a variety of oils: simple linseed oil, which takes a long time to dry, and stand oil and sun thickened linseed oil, which dry faster and form a tougher film. All these are fine, depending on the speed with which you build layers of paint. But too much of these fatty mediums can make the surface terribly greasy and can produce future cracking problems. The same is true of a similar vehicle called Venice turpentine, which has a very gummy feel but is excellent for glazing in the traditional manner. Lately I've been using copal medium, a commercial preparation which is lighter than many others, easier to mix with paint, and quick-drying, allowing me to work easily on successive days without feeling a tacky "pull" on the surface.

Again, the paint vehicle or thinner usually fits the way I want the paint to flow, the character and size of the painting, and the kind of paint surface I feel comfortable with. Years ago, when I generally favored an active, highly visible brushstroke in the spirit of Sargent or Duveneck (see *School Band*, page 80), I used stand oil, thinned with turpentine; this gave a fluidity to the brushstroke and also held its character when the stroke was dry. My current painting is more pigmented in texture, and, if anything, I tend to use *less* thinner or medium than ever. These "rules" aren't rigidly applied, as some of the demonstrations will show.

Study for Portrait of Freddy, *1964, oil on wood, 8" x 11" (20 x 28 cm). This was a study for a commissioned portrait. Because the girl lived in Philadelphia, it was essential to do this kind of detailed study to take back to the studio where I did the final painting. The study is all* alla prima, *but the darks are rendered in transparent washes, which give this small sketch a special richness of texture.*

Remember that the general rule about the use of these mediums is "fat over lean." That is, use less of these oil mediums in the early stages and more at the end. The reasons are both practical and aesthetic. "Fat over lean" looks better and prevents cracking.

I should also mention that I've tried using resinous gels as a medium, but with mixed success. Actually, I've found them excellent for small oil sketches, since these gels combine great fluidity with relatively good drying time, and they hold a brushstroke with remarkable fidelity. The dried painting still looks almost "wet." But my method of building a painting is often riddled with changes of a dramatic kind—even to the point of painting out and redoing whole areas—and I no longer aim for that "wet" look in the finish. So gel is no longer the right kind of medium for me. And note that some of the gels on the market don't really dry; the surface of the picture seems to remain oily years after, accumulating dust that may be impossible to remove. But I'd still advise anyone to try the gels—or any of these mediums—since their efficacy depends so much on one's personal preference about the "feel" of the paint.

Canvas, Panels, and Other Surfaces

Clearly, my choice of brushes and medium is influenced by the surface I choose to paint on. Canvas is obviously the most versatile support in terms of size, texture, and flexibility. From a very early time, when I learned rigorous technical procedures for preparing canvas, I've tried to work only on linen canvas, primed with white lead. There was a time when I prepared my own canvas in this traditional way. I'm not such a purist anymore. I still insist on linen canvas, which I prepare myself with a simple application of acrylic gesso. This eliminates the necessity to size the canvas with rabbitskin glue, plus the long drying time required of a white lead oil ground. I also have a supply of fine triple-primed Belgian linens which I've collected over the years.

The canvas texture varies from a very fine weave to a rough, burlaplike, heavy weave. I prime the surface with two or three coats of acrylic gesso, scraping the paint between coats to eliminate the bumps. This leaves the canvas texture intact but gives the surface a varied, less "mechanical" look. Scale is important in determining just how smoothly I'll finish the ground. Generally, I want a small canvas to be fairly smooth, though I *have* used rough-textured canvas on some small paintings.

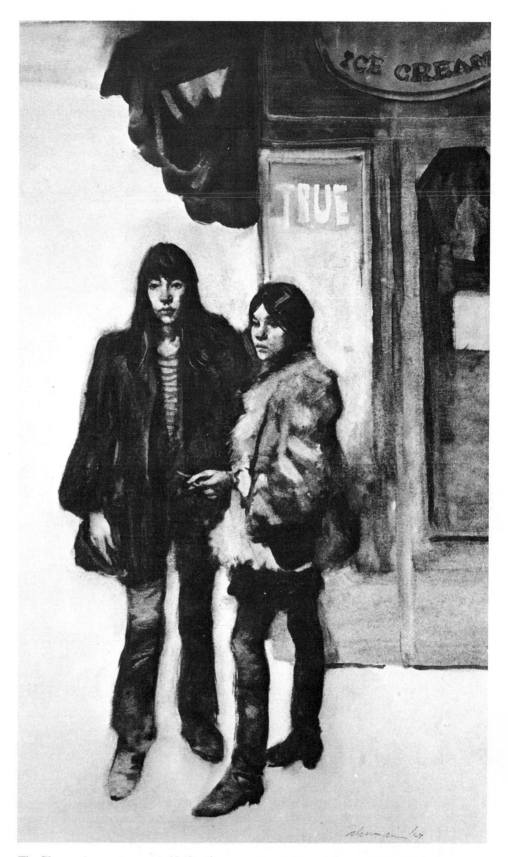

The Shower *(opposite page), 1968, oil on sized paper mounted on board, 13" x 19" (33 x 48 cm), private collection. Because this surface had a grain almost like charcoal paper, my rendering approached the method I might use with pastel. I wish I could retrieve this picture for a few small adjustments to an otherwise satisfying painting.*

Candy Store *(above), 1969, oil wash on Fabriano paper, 22" x 28" (56 x 71 cm), collection Jon and Dorie Freidman. This painting is an example of the versatility and graphic range that can be achieved with an oil wash where the paint is thinned and used like watercolor. The drawing is a combination of burnt umber and burnt sienna.*

I also paint on hardwood panels, primed with a half-and-half solution of shellac and denatured alcohol to protect the wood fiber and seal the surface against absorption of moisture. Panels of this kind (¼″ to ¾″ thick) are a long-time favorite of mine. The close grain of the wood receives the paint beautifully and is great for small studies—in which you can be as loose or tight as you wish—and such pictures are virtually indestructible, barring earthquake, tornado, and careless moving men.

Gesso panels on ¼″ Masonite are also tough and interesting for smaller paintings. There are commercially prepared panels, but again I prefer to do my own with acrylic gesso. (There are several acrylic gessos available, but many are too "rubbery," and I find that Liquitex gesso works best for me.)

I also like painting on paper—usually a good 100% rag board which is sized with the same shellac solution I use for wood panels. I've found painting on paper particularly relaxing and casual—with a consequent sense of freedom in the work—compared to the preparatory hassle I sometimes experience with canvas. Paper has quite a different feel from all the other surfaces and seems to suggest monochromatic images. In fact, I generally use it to make oil wash drawings in sepia and umber, thinned with a lot of turpentine. I wash out certain areas with turpentine to get my whites or accents.

Let me get back to canvas again for some final observations—which are actually relevant for all the materials I paint on. I usually dislike working on a white surface. My early training, which took its cue from the dark-toned canvases first developed in the late Renaissance, taught me to tone all my canvases. I still feel most comfortable doing that. I prefer a brownish, greenish, or grayish middletone—though I sometimes use lighter tints—over which I brush in the drawing loosely, usually with burnt sienna thinned slightly with turpentine, and then add local color and lighter tones to complete the value range.

My most recent grounds have been applied with a palette knife to build a paint surface that has an uneven and patchy quality. I generally use very *light* tints here.

I also love to paint on old canvases on which I've abandoned an earlier painting, either leaving it unfinished or partially scraping it down (see Demonstration 1, page 52). Such a surface has a richer texture than bare canvas, can shine through to create delicate color

nuances, and can complement and enhance the pigments applied in the finish. Of course, the "underpainting" here is the old picture, which is naturally different from the one drawn on top, but I love the randomness of the underlying values, the disparity of the old and new colors, which give the new picture an immediate sense of texture and density and also make me put the fresh paint down in a broader, flatter sweep. In order to see the *new* painting clearly, I must concentrate that much more intensely to hold onto a clear idea of what's essential, eliminating trivial (if engaging) details.

But let me note that there's some danger in this method, since there's no reliable way to guarantee a fat-over-lean buildup of the paint or to make certain that proper adhesion is taking place. So far, I've had no serious cracking or restoration problems in most of my work. But there *is* a potential problem with *pentimento*—the Italian word for the translucency of old oil paint. As a painting ages, the color becomes increasingly transparent and allows the lower layers of paint to come through. If you have a different image underneath, this can eventually spell trouble.

I mentioned Chardin before, and it might serve the reader to look at his work to study this buildup of textured layers of pigment, particularly in the light-struck, opaque areas. His surfaces are dense with subtle color variations, yet the feeling is one of extraordinary freshness and simplicity. These opaque passages provide an elegant counterpoint to the luminous, glazed darks, and these varied technical devices combine magnificently to promote the reality of his images.

Developing the Painting

While I have a general set of working procedures, it should be clear by now that I'm prepared to use any device that serves the needs of the finished picture. For example, if I'm doing a study for a picture—on a panel or a board—it's usually a predominantly *alla prima* painting, painted in one operation. Since I work very quickly, I can arrive at a fairly complete image after a very short time, probably no more than three hours. If it's a portrait study, for instance, I can get all the relevant details of features and gestures in that one sitting. My small-scale pictures exploit rapid brushwork and fluid paint. Because they're done quickly, these paintings generally have great spontaneity.

But trying to get that spontaneous quality into a larger, more "finished"

picture can be a hopeless quest—and I must admit that many a painting has fallen victim to this kind of misdirected effort. In large, complex pictures, the paint does appear to flow less freely on the canvas. Certainly, there are dramatic examples of artists who've successfully achieved a sense of free-wheeling, uninhibited brushwork in large scale works—like Sargent, Boldini, and Henri, among many others—but I must emphasize that this quality cannot be the *goal* of the picture. The brushwork really has to be a genuine outgrowth of the way the image is actually arrived at: quick and spontaneous for some painters; slow and exploratory for others.

My larger works tends to be more considered—sometimes changing course in their development—than my small sketches. I do feel that certain qualities *associated* with spontaneity—like directness of color, simplicity of form, and a sense of vitality in the paint quality—are all valuable in a work of art. But my temperament (and therefore my taste) has shifted gradually over the years, so that I now find the greatest satisfaction in the images, not just in the paint. I prefer a paint surface that seems "time saturated." That is, I build up the paint more slowly, and my forms seem to have more solidity.

In practical terms, I have to slow down the development of the details of a picture. I have to keep postponing that rendered, finished look. I wipe out or paint over portions of the painting that seem too literal. I try to concentrate on the big, simple forms and use detail sparingly.

Before I start a painting, I usually try to establish the dominant color mood. Will it be a cool palette—blues, reds, and purples—or a warm one with earth colors, yellows, and greens? By limiting the color scheme to a few predetermined tones, I feel I can enhance the expressiveness of the painting. I can also simplify my color choices. Of course, while the painting may have a decisively cool or warm thrust, I very often include complementary color notes to enrich the tonal scale and also to accent some significant part of the image.

As the painting develops, I try constantly to match the painted image to my initial vision. I don't always succeed. I remember working on a painting of my wife and son in our house in Italy. There were many problems. The light source was very diffuse. The angles I'd chosen presented more than the usual drawing problems. And the subject matter—Claire reading to Bobby—was in danger of lapsing into sentimentality.

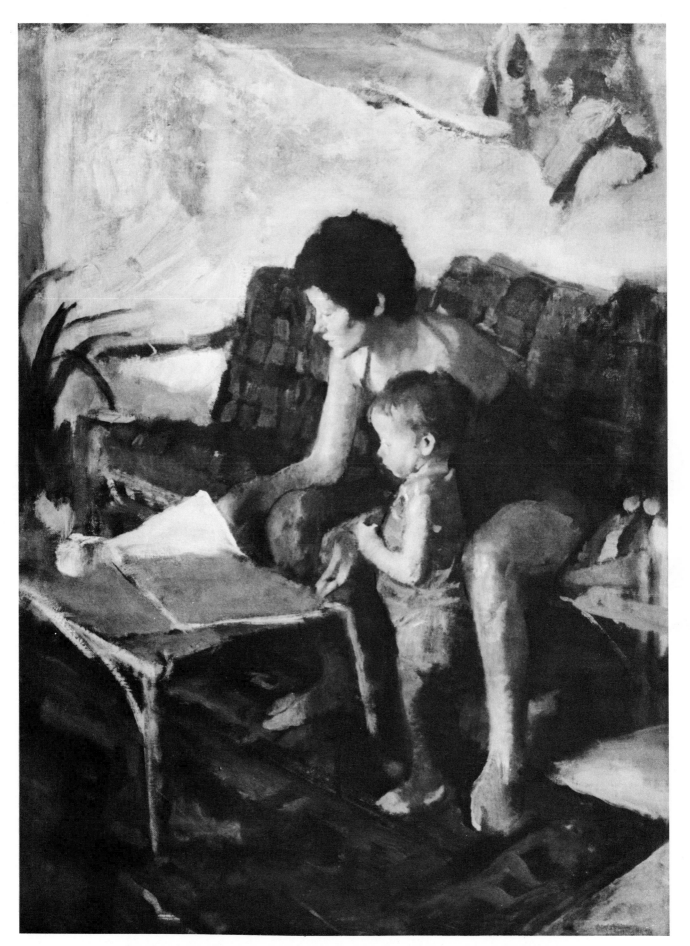

Untitled, *1974, oil on canvas, 46″ x 32″ (117 x 81 cm), unfinished. Although I worked on this painting for roughly a year, I finally abandoned it for reasons which I describe on pages 32 and 34.*

The image did represent many deep, warm feelings—I'm certainly not opposed to *sentiment*—but the picture required just the right gesture and characterization (especially in painting the little two-year-old) to bring it off. Though I worked on this painting on and off for about a year, it was finally abandoned.

As you can see in the *Untitled* version (page 33) shown at about midpoint in my struggle, all the basic shapes have been clearly stated. The heads are fairly close to completion. But something began to happen as the painting sat in the studio. I became dissatisfied. The painting seemed trivial and overly "sweet." The placement of the figures, while "accurate," seemed clumsy with all those legs, all those thin forms, smack in the middle of the picture. I got caught up in trying to change the colors to offset this—and lost the feeling of light. The painting ultimately lost its impact for me, and the struggle no longer seemed worth the effort.

I did another picture some time later (see page 104). This is essentially the same idea but with a different arrangement of forms. The *first* painting was ultimately insoluble after all, but there was no way of knowing this until I'd gone through the process to the bitter end.

Pastel: Materials and Methods

Degas is reported to have said that he would have preferred to make only drawings, but that public taste demanded color, so he made paintings.

This quixotic remark from an extraordinarily versatile colorist, reveals something of the attitude that led him to use pastel almost exclusively at the end of his career. It also expresses much of my own feeling about pastel: it is the perfect compromise for the draughtsman who must use color. Like all painting materials, pastel is better suited to some kinds of pictures than to others. And, like all media, pastel has its limitations. You can't work over a pastel painting indefinitely, certainly not as long as you can work over an oil painting. Pastel isn't suited to really large-scale pictures. And pastel's soft, crumbly quality inhibits the artist whose style is linked to juicy, fluid brushstrokes.

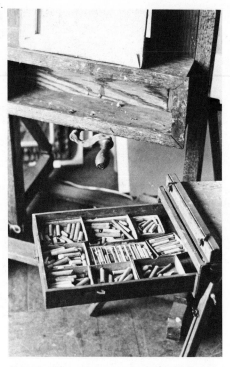

Pastels. *These were separated into homogeneous colors and stored in a portable painting easel.*

Nevertheless, pastel offers a great range of possibilities, from highly finished surfaces to the most elusively suggestive images—and many variations between these two extremes. Pastel can approximate the density of oil, be luminous or flat, and has the added virtue of a continuously workable surface, without worrying about drying time.

Chalks

Pastels come in varying degrees of hardness. I try to find the softest variety, provided that they're not too fragile. I buy the sticks individually—not in sets—since I can get a better range of colors, suited to my specific palette. My pastel palette is essentially the same as my oil palette—the same selection of hues, but, naturally, each hue is represented by a range of pastel sticks, running the full gamut from light to dark. I store them in small boxes, and when I can get around to it, I line each box with aluminum foil. This keeps the chalks from rubbing off on the interior surface of the box and hence keeps the individual sticks relatively free of a gray, dustlike patina which can obscure the color. It's hard enough to keep track of the colors while I'm working: if they all look like some variant of gray, this slows down my working time enormously.

In addition to well known manufacturers like Grumbacher, Weber, and Rowney, there are smaller, independent producers of pastels (like le Franc) whose chalks are extraordinarily soft, intense in color, and only slightly more fragile than commercial sticks. The interested student can also make pastels himself.

Surfaces

You can use pastels on almost any paper or canvas, though some prove more effective than others for holding the chalk dust. That's really the main technical problem, and has caused untold anguish for those artists who use pastel with any degree of sophistication or intensity. I'll get to this in a moment.

There's a commercially prepared pastel canvas I've used extensively in the past: a cotton fiber coated with a fine abrasive dust and sold in three-foot widths. I usually tone the ground by blowing on a solution of turpentine tinted with some oil color—either an ochre or olive green—and allowing this to dry. I haven't tried this yet, but it's certainly possible to start working immediately on this wet surface. I read recently that Degas soaked his paper in a turpentine bath before commencing to work on it. The first lay-in of colors produces a different quality on this damp paper. The colors will be darker and grittier—so adhesion will be better—and the chalks will behave more like oil pastels, which, incidentally, are quite popular in Europe.

Good rag boards, with a reasonable amount of "tooth," make excellent surfaces. Pastel papers, tinted or colored in varying shades, are also good and are extremely versatile for studies. I prefer the lighter tints of paper on the principle that a middletone offers a better ground for setting the final color key.

As the chalk piles upon the paper, all these surfaces will eventually lose their ability to grab the chalk. It therefore becomes necessary to spray successive layers of fixative ever so lightly over the whole painting—like a snowfall. This keeps the fixative from darkening the lighter colors and from forming a smooth film, which is *not* what I want. The fixative holds the individual grains of chalk and these little particles can grip more color. In this way, the life of the surface can be extended a great deal. By fixing each successive layer of color, I can preserve the color "counterpoint"—applying one layer of color on top of another—and build a meatier surface without any danger of it all turning into a chalky mush.

Working Methods

As in the other painting mediums I've described, I start by drawing on a toned

surface, but with a soft vine charcoal. Ultimately, most of these first lines are either completely lost or just barely visible at the finish.

Recently my pastels have tended to be less linear, with almost all forms described by broad areas of flat form—color areas that are relatively unchanged by modeling. If the drawing is right, only a slight degree of modeling is required; only the most significant grays or darks are necessary to "turn" the form. In this sense, my pastels have become more like paintings and less like drawings. Consequently, I use the side of the pastel chalk more than the tip, but still allowing successive layers of rendering to come through.

I can model the form by changing the pressure I apply on the chalk. For example, when I begin to render a head, I'll place light values (pinks or pale yellows) in those areas of the face that are most strongly illuminated. As the form goes toward the dark, I'll begin to ease off pressure on the chalk, allowing it to just skim the surface of the paper. This permits the darker ground color to come through and influence the form, though this underlying tone is modulated by the strokes laid over it. This interaction between two separate layers of colors produces what are often described as "optical grays." No physical mixing takes place, but the two layers of color "blend" in the viewer's eye.

This optical mixing is a venerable method, going back at least to those oil paintings on dark grounds in sixteenth century northern Italy. And the Impressionists made optical mixtures of complementaries by mingling strokes of cool and warm colors, leaving them unblended and allowing them to blend in your eye.

Fixative
In the middle and late stages of the painting, I use the fixative spray more and more frequently. My main purpose is to keep the later layers of chalk from falling off, to make the whole image more stable and less vulnerable to damage. Occasionally, I spray a passage very heavily to darken the colors on purpose, so I can add fresh corrective layers on top. This can be tricky, since it's not always easy to control the aim of the spray. Cutting a rough mask out of some smooth paper can make this procedure more accurate.

In the beginning, it's far easier to make wholesale changes in the drawing or in the composition, with the aid of a forceful blast of fixative. But once I have a substantial amount of pastel on

Discotheque, 1969, pastel on board prepared with rottenstone, 20″ x 36″ (51 x 91 cm), private collection. The excellent gripping capacity of this surface was put to the test in this pastel, which underwent many changes before I regarded it as finished. Note that there are still some drawing lines showing through at the bottom of the picture and to the left of the second girl's leg. Because of the active "drawn" quality achieved with the chalks, I feel that drawing lines are consonant with the spontaneity of the painting.

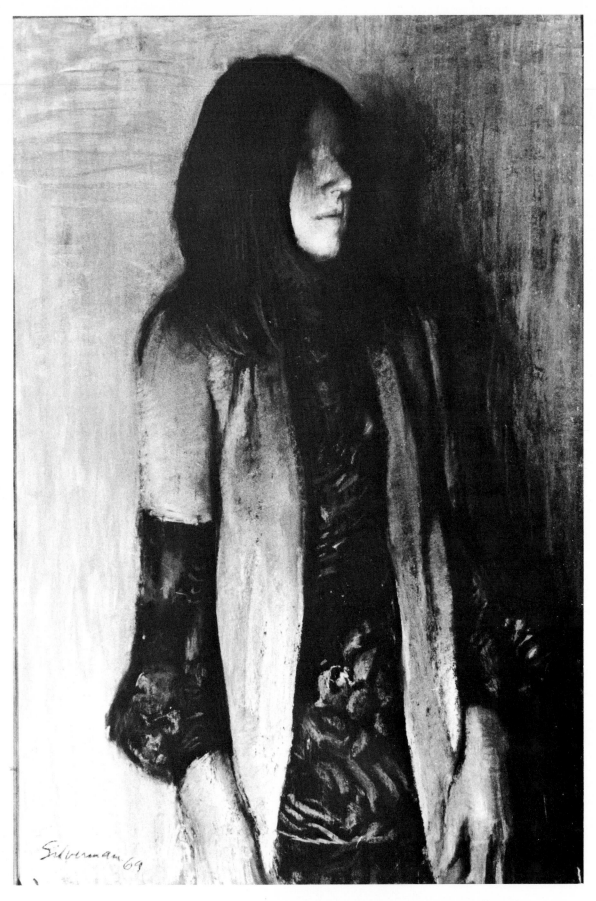

Kings Road Girl, *1969, pastel on canvas, 15" x 22" (38 x 56 cm), courtesy Gallery 52, South Orange, New Jersey. Here the pastel is used in a more painterly fashion, though there are still traces of scratchy vertical and horizontal chalk strokes. Essentially, though, the lights are constructed of broad sweeps of the chalk, using the long side of the pastel stick.*

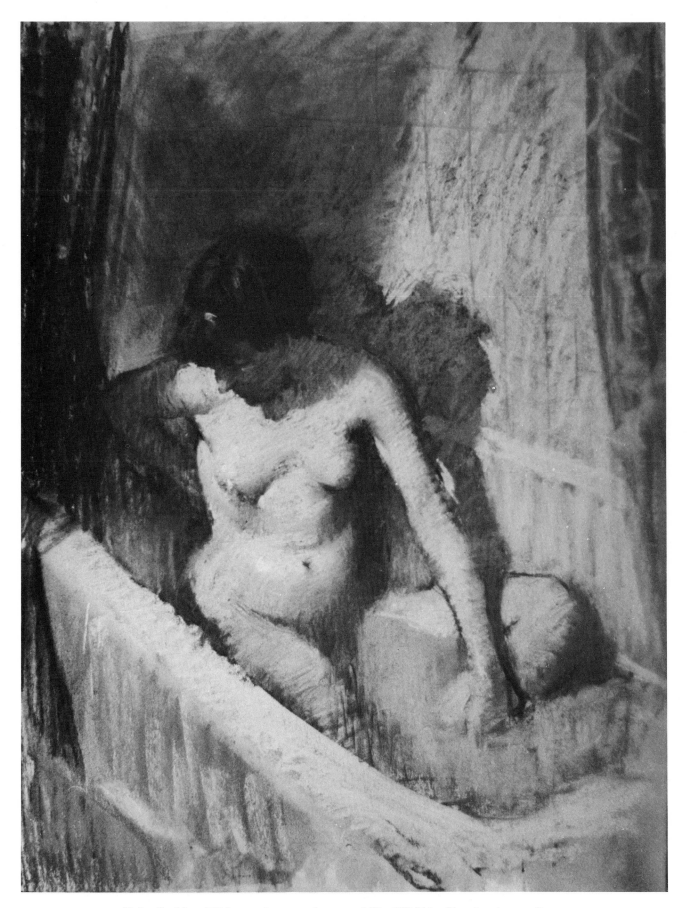

Helen Bathing, *1965, pastel on pastel canvas, 18" x 20" (46 x 51 cm), private collection. This picture demonstrates the great versatility of the canvas on which a variety of strokes all come together in one image. Because the surface is almost smooth, the strokes range from a scrawled line to flat covering scumbles (as in the base of the tub) to the most delicate shadings in between. This is accomplished without the intrusion of an obvious paper or canvas grain to vitiate them.*

the surface, I've got to be more careful about making changes; I've got to be more selective and more certain about these changes before I make them.

The Pleasure of Pastel
I must say that my experience with pastel has given me more consistent pleasure—if that's the right word—than either oil or watercolor. I suspect that this pleasure has much to do with the closeness of pastel to drawing, which I love, as well as the general tractability of the medium. Knowing that changes or corrections are fairly easy to make *and* actually increase the richness of the surface—which is less true with oil and a real deficit with watercolor—makes me feel looser and freer to concentrate on the aesthetic demands of the painting. The quickness of the medium, plus the fact that there's no drying time, adds to the general comfort.

All in all, pastel is an enormously appealing medium, and I suspect that I've used it very often just as a relief from the problems of oil or watercolor.

Watercolor: Materials and Methods

I started painting in watercolor as a kid of nine, and have continued to use it ever since—with a mixture of pleasure and anguish. Like the little girl with the curl in the middle of her forehead, the medium is both delicious and problematical. The transparency of the pigments provides lightness, spontaneity, richness of color, and relative speed in making an image. But these advantages are balanced out by the difficulty in making corrections—or wholesale changes—and the galling loss of control which sometimes happens, when all seems to become lost in a buckling puddle of mud.

Of course, many of these problems can stem from using second-rate materials. Cheap paper, bad brushes, or poor quality paint—or all three—can turn inspiration to aggravation in a flash. So it's essential to buy the best you can afford.

As I began to use watercolor more frequently in painting outdoors, I began an active investigation of ways to reduce these problems, and to minimize the difficulties.

To start with, if you want to paint outdoors, you must be able to move easily, set up quickly, and work without stumbling over your equipment. An efficient, smallish box to hold your paint, brushes, and mixing surface; durable, nonbuckling paper that can be held on your lap; and a bottle to hold water so it doesn't spill in transit—these are all fundamental requirements.

Finding the Right Paper
The chief problem has always been the papers I used. They were generally good quality rag paper, from 72 to 140 pound weight, but I found that they all buckled more than I cared for. And, if they didn't buckle, the grain was so coarse that it seemed to be the dominant element in the painting. Taping down the edges, buying "watercolor blocks" (a stack of sheets bound together along all four edges), preshrinking the paper by wetting it and *then* taping it down, all seemed like compromises and not very satisfactory ones at that. Another problem was the difficulty in making changes rapidly—or at all—changes that could involve whole areas of color, specific bits of modeling, or even a bit of drawing. No, this was not like oil painting, where you could wipe, scrape, paint over, keep piling on paint to correct things—and turn these corrections into a "plus" because they produced a rich paint surface.

Thus began what may seem like a search for the surfer's "perfect wave." I started to use other kinds of papers—various nonabsorbent, heavy rag papers—and I dry mounted some of them on board to keep them flat. In addition, I found that I could minimize the buckling by holding down the size of the painting, since less water was needed to cover a given area.

Gesso-coated Paper
Then, as a result of seeing David Levine's work on very smooth-surfaced bristol board, I started experimenting on gesso-primed surfaces, usually on a good quality rag board. (I started with Whatman paper, but they've since gone out of business, and the remaining stocks in art stores have also disappeared; I've successfully used boards of similar quality, like Strathmore rag board.) The gesso—readymade acrylic gesso, which allows for the flexibility of the board—was painted on in several coats, usually two medium heavy layers, then allowed to dry for at least twenty-four hours.

The longer the drying time, the better the surface was for receiving color *and*

for wiping out, since this latter quality was what I was after. I wanted to be able to change whole sections of painting, if need be, so as to approach the same degree of working ease as I had with the oils. For a while, this worked very well. I could indeed get back to the white of the paper with just a wet brush.

However, there were drawbacks. The layering of color—that is, the application of many layers of transparent washes, which accounts for some of the richness and visual complexity of the medium—was severely limited by the "wipability" of the paint. And the paint behaved unpredictably from board to board as well, so that I was never quite sure what was possible in each painting. Furthermore, the intensity of the color varied with each new board. Some colors retained their richness; others went gray and lifeless. Also some colors—particularly Prussian blue and alizarin crimson—would stain the paper and would not wipe away easily.

Despite these problems, I learned very soon to detect how the gesso-coated paper was going to work, and I managed to go for several years with this kind of surface. Because I so favored the one quality it did have—the ability to wipe away easily—I overlooked the other limitations. But I was never quite content. Then, what eventually turned me off gesso-surfaced paper was the breakdown of the process altogether. For some reason (maybe the manufacturer changed the formula) the acrylic ground just refused to operate at all! When the paint went on, it looked washed out; it would develop blotchy runs and was generally impossible to control.

Illustration Board and Bristol
I began to search for other paper that would satisfy the primary demand of "wipability," as well as the secondary, but increasingly important, need for a predictable surface that would hold the color, reveal the paint stroke, and stay flat through the severest reworking and rewetting.

I turned to rag illustration board with a smooth "plate" surface. More difficulties. The paint didn't "move" easily. Then while in Italy one summer, I discovered interesting clay-coated paper (which was bonded to a cheap cardboard by the manufacturer) and I began using it quite extensively, though not without apprehension. The cardboard backing worried me, since I knew it probably had a high acid content. Despite these apprehensions, I found the paper fairly serviceable and in many

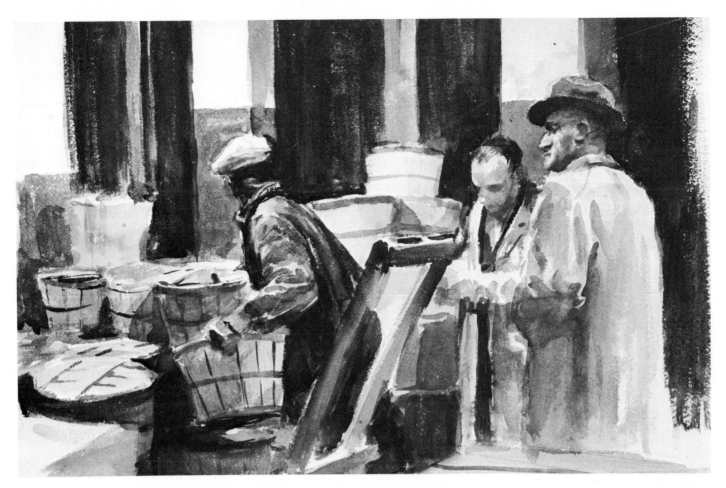

ways easier to use than the others. However, it did suffer from the same trouble as the gesso papers: the color tended to wipe off the surface too easily, and it was difficult to build layers of deeply saturated washes. Nevertheless, I'd still be using it now if my supply hadn't run out. I haven't been able to find any more.

In the last year or so, I've finally settled on a five-ply plate bristol, dry mounted on rag board. This is most effectively done with a dry mount press (used primarily by photographers) which is like a huge version of the hot iron used to iron shirts. A sheet of waxy paper, called dry mount tissue, is slipped between the paper and the board, and this "sandwich" is slid under the dry mount press, which clamps down, heats the "sandwich," and melts the wax. When the "sandwich" is removed and allowed to cool, the paper and board are neatly bonded. This method provides the most consistent adhesion and will last a very long time.

For a temporary bond, you can use rubber cement applied to both paper and board and then allowed to dry before you press them together. But you must remove the paper from the backing soon afterward and clean off the cement, which will otherwise eventually stain the paper.

As with more conventional paper and watercolor "blocks," I found that I had to proceed rather carefully with the initial drawing and the lay-in of the color on the mounted bristol. But this paper is very durable and will permit a good deal of washing out. The paint can be wiped out while wet or after it dries. Experience will soon show the limits of the surface. For example, soaking the paper too much will "feather" the surface—that is, cause bits of fiber to come off and thereby ruin future applications of paint. In the main, I've found it best to proceed with as carefree an attitude as possible, since there's nothing more constricting than a preoccupation with potential problems in one's materials.

Paints and Boxes

Unless you use watercolors constantly, the colors in tubes tend to dry out. I also find it bothersome to carry a box full of tubes and squeeze out colors when I'm eager to start painting. To ease the burden of hauling many tubes of paint, I started using cakes of color in what are called half-pan or full-pan boxes. This is often helpful in starting to work more quickly. (As a landscape painter, I often found the "model" quite impossible: scenes would literally evaporate into a grayish blah as the sun suddenly disappeared behind clouds which appeared

The Wholesalers, 1955, watercolor on 90 lb. (41 kg.) cold pressed paper, 11″ x 19″ (28 x 48 cm). This and the next three works are all examples of the progressive change that occurred in my watercolors— dictated in part by the change in papers. The painting shown here is constructed in "classic" watercolor fashion—working from lights to darks in successive applications of washes, taking care to leave the lights open and clearly accounted for.

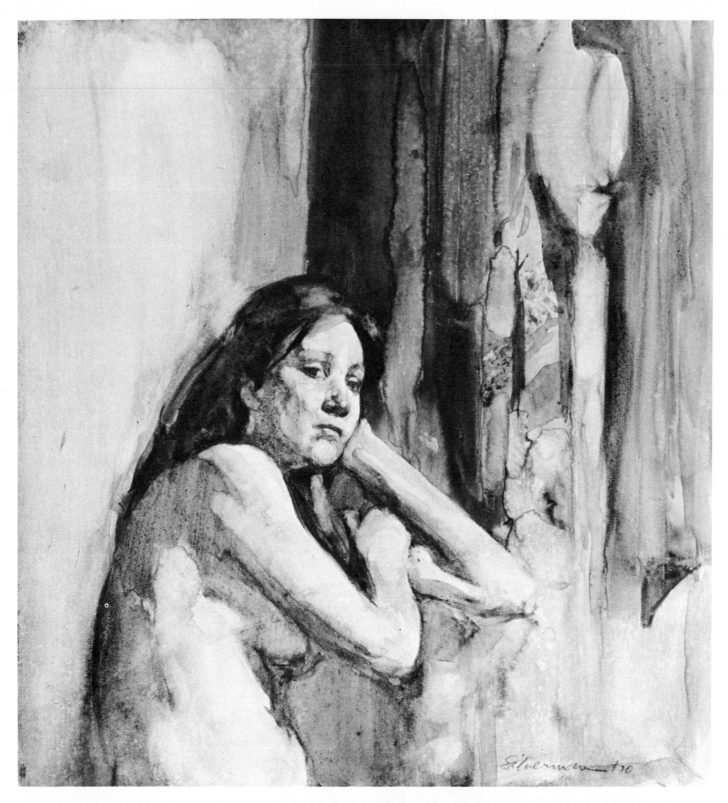

Model with Patterns (above), 1970, watercolor on gesso-coated rag board, 13½″ x 14½″ (34 x 37 cm), collection Rutgers University Stedman Fund. Here I did extensive wiping out of the forms, from light to dark, as in the torso and shoulder of the seated figure. The gesso surface made other qualities of the watercolor more active, such as the highly visible washes in the background drapery.

Study for The Marble Cutter (right), 1973, watercolor on clay-coated paper, 7″ x 11″ (18 x 28 cm), courtesy FAR Gallery. This paper, which I found only in Italy, was somewhat more capricious the first time I used it than the gesso-coated paper. Nevertheless, with some experience, I found it to be extremely dependable. The method here is the same as with the gesso-coated paper, but the look of the paint is different: it has no grain whatsoever, and the color loses little of its saturation or intensity in the drying.

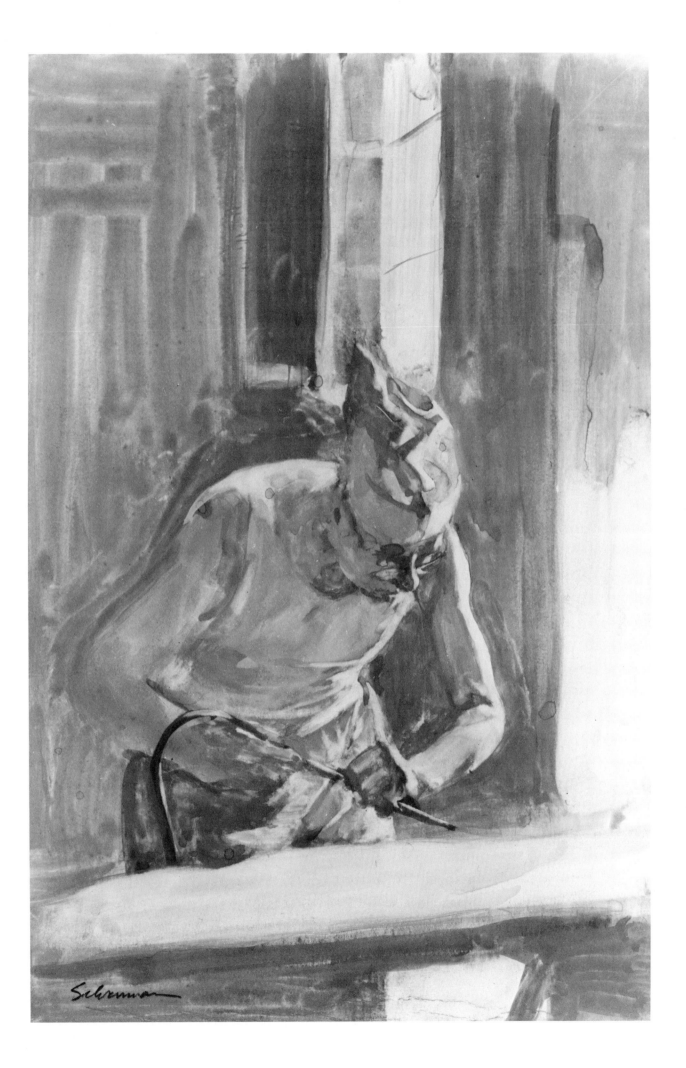

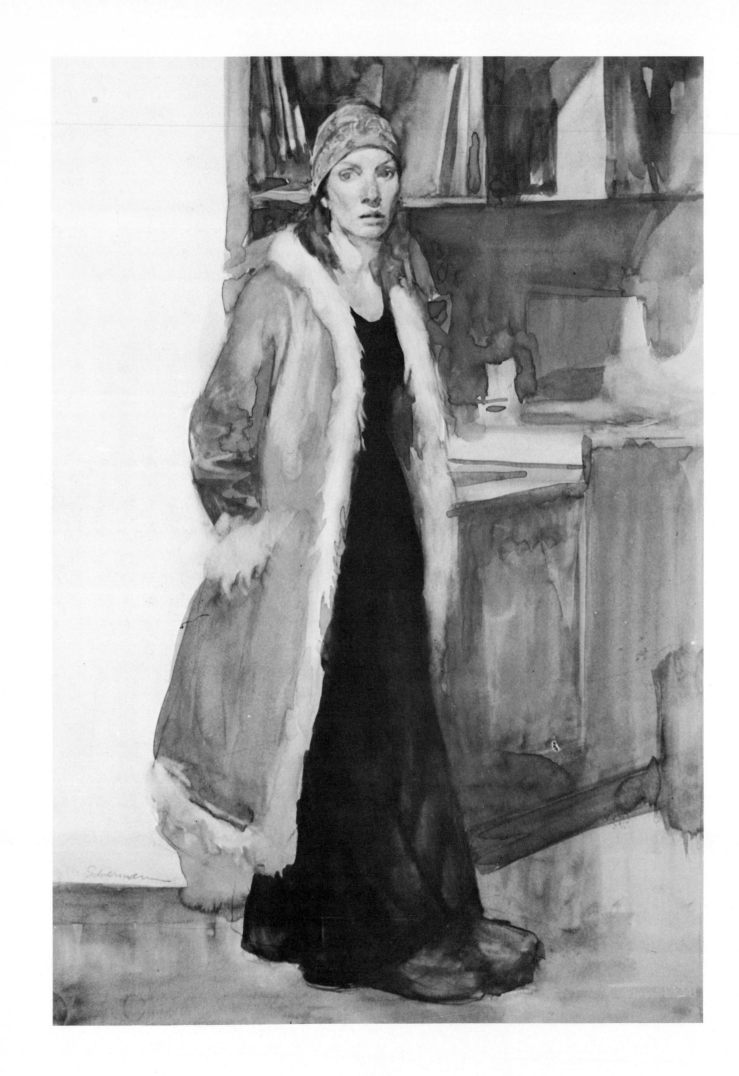

from nowhere!) I've continued to use them to this day, though now that I paint in the studio most of the time, the need for speed has been eliminated. But I still find the cakes convenient.

As far as quality is concerned, I have no special preference for either tubes or cakes. The paints in either one—if they are the best quality—seem the same. But tube colors present a problem in storing, since most watercolor boxes are really ill-designed for more than ten or so colors. The large selection of cakes are always ready and require only a bit of water to make them wet enough for use. Like tube colors, cakes can be bought individually to suit one's palette.

More important is the kind of box and the amount of mixing surface available. If you need a lot of paint for a picture larger than 10" x 15" (25 x 38 cm), you can use *any* porcelain-coated surface for mixing the paint. (Small porcelain butchers' trays serve well here.) But certainly, the larger the surface in the watercolor box itself, the less hassled you are in the use of the medium. After much experimentation, I've found a box that has room for eighteen full-size cakes, plus two good-sized "wings" for mixing. I've often used the cake pans ad lib fashion—by squeezing tube color

into them when the cakes ran out.

I usually prefer a wide assortment of earth colors (as with the oils); two good blues, the powerful Prussian and the more subdued ultramarine; two greens, viridian and chrome; two reds, alizarin and vermilion; lamp black; and, in recent years, an opaque white gouache. The reason for the last is to gray out the values of colors used to model the form, since I now want less contrast in the light and dark transitions in a face, for example. This implies "flattening" the image—turning it toward a simpler shape, rather than rendering every change of color or light and dark.

Brushes

Brushes are the simplest, yet most expensive tools I use. I need (and normally use) three kinds of brushes: a large, round wash brush that still provides a good point to articulate a given shape, like the background to a figure; a small, pointed brush for details; and a middle-sized, round brush that will hold a lot of paint and also give a relatively sharp line. These are hard to find. The best brushes still come from Europe, though domestic equivalents are sometimes serviceable. The basic demand of a well-functioning brush is

Watercolor Table. I use two kinds of palettes, both very similar. The second palette is most useful for extra mixing space and duplicate colors in case I use all the colors on the first one while I'm working. Note that both palettes are constructed to take watercolor "cakes."

The Art Student (opposite page), 1975, watercolor on rag (plate Bristol) 14" x 20" (36 x 51 cm), courtesy Gallery 52, South Orange, New Jersey. The virtue of this paper lies in the velvety washes that can be obtained (for example, in the blacks of the pants) and the graduated, rubbed-out whites (as in the arm of the coat). This quality clearly allows for a wide range of textures and a rich image-making potential.

durability. Unfortunately, as with all other materials currently produced for artists, this quality has suffered enormously in the last twenty years.

Starting a Watercolor

In setting up to work, I find it useful to arrange the palette, brushes, and water so that they're almost automatically within reach. The paint box is closest, on my right. Nearby are the water container and the brushes. I hold a piece of paper toweling in my left hand. I select a board from an inventory of at least half a dozen or more, prepared in advance in my "off hours." Size and shape reflect the demands of the image I have in mind. Now comes the tough part. I have to make the single most important decision. What will be the tonal and color limits of the painting? Will it be a "cool" picture (grays, blues, soft pinks) or a "hot" one (earth colors or yellows and blue-greens)? The decision comes from the model: what he or she, as a person, seems to "need" visually and psychologically to make the most effective image. The first wash I put down, therefore, will "commit" me to that decision throughout the painting of the picture. Changes of mind—a frequent affliction for me—will often be difficult to correct. So, I often wipe and start again.

As with the oils, I start by stating the general "proposition" of the painting. That is, I put down the abstract qualities of the image. Sometimes I *lightly* draw the general outlines of the figure or figures *before* I put down any color. On the other hand, I sometimes lay in an overall color; then, when the paint has just begun to stabilize (when it's not absolutely wet or runny) I wipe out the light areas of the image, either to the white of the paper or to a lighter tone of the wash that covers the sheet. This differs from the conventional watercolor method in which the whites are absolutely planned in advance and the washes are accordingly laid in from light to dark, leaving the whites untouched. Now, if the painting is very complicated, I will again draw lightly over the colored ground at this point to indicate supplemental figures, background, or other secondary elements.

There's no one perfect way to paint a watercolor. As in other media, I think it's important to let the image dictate the means. While this may seem baffling, even overwhelming, initially, the method *will* sort itself out in the doing. It's terribly important, especially for the student, to try different ways and allow for the strong possibility of failure.

Developing the Painting

As a painting develops—as the forms begin to take shape—I often pause and reflect carefully on several points. I think about the *feel* of the painting at this state. Are the overall color, composition, and conceptualization really okay? How much rendering of form and detail is now required—and where? I find that the more I pause and consider during a painting—the *less* I do—the fewer corrections will be required.

Another note: while accidents often look terrific, "happy accidents" cannot be relied on. As with no other medium, watercolor demands a high degree of certitude in your drawing ability. Even with this certitude, I find that I can lose control of the situation.

Throughout the painting process, I want to keep my options open. A wash looks different wet than dry, especially on the paper I use. It's therefore important to let the image cohere slowly. Colors need to be *layered*. And, though many artists like painting wet-in-wet—they enjoy that feeling of the colors running together—I prefer that the colors stay in distinct areas. This doesn't mean that everything is completely defined. Quite the contrary. As the painting develops from the general to the particular, I exercise very clear judgment about how far I will carry the rendering of the form in each passage. There's a selective, uneven degree of finish in much of my work. Parts of the form are sometimes deliberately left vague, suggestive and loose. I'll often run a cast shadow into and around a figure. Boundaries become lost, then reappear in another place as the figure melts away and then reasserts its physical presence.

Sometimes I do have to backtrack and wipe out a particularly "nice" passage. The joy of rendering is my addictive weakness, and I often get carried away by the "high" of a beautifully drawn or painted passage.

As the image progresses to a finish, I also have to be alert to hold onto the "life" of the painting. Watercolor thrives on spontaneity. But this isn't an "effect" to be consciously sought after. Effects, devices, and technique alone are all contrivances and fail to stir me. The spontaneous qualities that come from the "means" of making the painting will be apparent if they are genuine—that is, if these qualities develop as a *result* of the search for the *meaning*

of the image. Nor are there any "rules." Even a muddy color—often the cardinal sin in watercolors—can sometimes be a powerful element in the ultimate effectiveness of a painting.

I try to delay making a final decision about forms, color, and drawing until I'm quite certain that they're right. This means more waiting—sometimes even leaving a painting for several days—until the right things or the wrong things assert themselves. I discard a great many paintings. It's easier for me to throw out a watercolor, since the investment in time and energy is often less than with oils. But that's not the only reason. Very often the painting begins to bore me. I've become more demanding about what should survive, though at rare times I confess that I've made a wrong decision and tossed out a painting I wish I'd saved.

Making a Painting

A student recently asked me how I make paintings: not what medium I use or what techniques I employ, but how my ideas get transformed into pictures. Although I've already said something about these issues in the pages you've read so far, perhaps I can put the whole process into perspective if I focus on a particular painting idea I've had, discussing the problems that occurred from beginning to end.

Sketches and Studies

First off, I'm always making paintings in my head, before I ever get to paper or canvas. I make frequent notes—thumbnail compositions to record ideas—during the course of the day.

If an image is particularly striking, then I begin to make studies: usually a single figure, or perhaps a group. Of all the drawings and studies, only a small percentage evolve into a finished painting. Making these studies is often a winnowing-out process, a way of sorting out the right forms for the final painting. And sometimes the studies or a small color sketch are as far as I carry the idea.

A Series of Paintings

But let's look at a specific painting—actually a group of paintings—that I've done of go-go dancers. My impulse to paint this kind of thing came from

Study for 12 O'Clock Dancer, *1974, pencil on page, 7″ x 10″ (18 x 25 cm). This drawing was done at a topless bar.*

strong, but contradictory feelings. On the one hand, the dance is sexually provocative. On the other hand, however, the dancers often reveal their hostility to men and the dance really caricatures the sexual experience in grotesquely exaggerated movements.

With this contradictory emotional character, the theatrical aspect of the subject exerted an even stronger visual appeal. The starkness of the theatrical setting, the almost nude figures spotlighted with exaggerated drama, the figures crisscrossing in an elaborate interplay of forms—all presented an extraordinary spectacle and challenge.

In undertaking such a difficult subject, how could I begin to depict the event and interweave all these strands of feeling? The dance is all movement, which is automatically a problem, since a painting is a fixed, motionless image. What combination of body movements best exemplifies the true character of the dance, and, at the same time, provides the most expressive moment to "freeze" on the canvas.

Drawings and Photos

I started by drawing the dancers over and over again—working in the semi-darkness of the theatre. I used an old press card to get permission to take photographs of the settings, as well as some blurry pictures of the dancers themselves. (These were the days just before the topless dancers, though the women were very scantily dressed.) I went back repeatedly to one place in particular, and finally made the manager nervous enough to tell me to leave.

Armed with these drawings and photos, I selected one or two images that seemed almost right and did pastels of them. I then changed the pose and the light and did several others. I hired a model, played rock-and-roll music, and had her dance continuously while I drew. Than I stopped the movement and did a small oil sketch from that "pose."

Developing the Paintings

At this stage in the process, I paused and began to reflect on what combination of figure, background, and setting I needed for the final painting. By this time I'd done many things, both pastels and oils, that were, in fact, finished works, but I viewed them as merely preparatory. Later on, I realized that there was no "final painting," that all the works had something valid to "say" about the subject. But, at this point, I settled on just the single figure of the dancer. I was less interested in the scene

Study of a Dancer, *1970, pastel on charcoal paper, 18″ x 24″ (46 x 61 cm). The model for this painting posed in my studio to the accompaniment of a rock record.*

Go-Go at the Peppermint Lounge, *pastel on Canson paper, 14" x 18" (36 x 46 cm), private collection. This was also posed in my studio to the accompaniment of a rock record.*

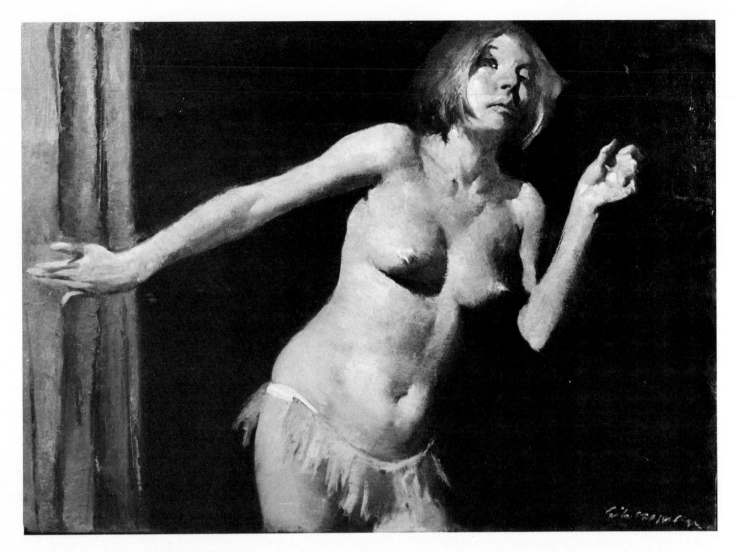

12 O'Clock Dancer, *oil on canvas, 13" x 19" (33 x 48 cm). This painting and the previous three drawings show four stages in the evolution of a painting. Here is the final synthesis of all of them, but a model was used only briefly. (See pages 130-133 for other paintings on a similar theme.)*

than in the psychology of the performer.

I also discovered that I had less and less need for a model or for any on-the-spot information. As they developed, the paintings relied more on what Wordsworth described as "emotion recollected in tranquility." In order to portray the images of these dancing figures most effectively, I needed to simplify and abstract more and more of the visual event. As Degas and Whistler emphasized, the best way to do this was to rely more and more on memory—and less on documentation—as the later paintings took shape.

I continued to do pictures of the go-go dancers for several years. The last—a small oil—was done in 1974. I finally selected a simple black background, with all the colors relatively muted to grays and pinks, the only strong color note being the tassled briefs. The figure is cut off just below the hips, with all the movement centered in the upper torso. The head is tilted upward, yet the eyes are looking aside, as if searching for something beyond the picture. And, while the pose suggests movement, the image is painted in a cool, studied manner, my intention being to suggest a tension and separation between the dancer's mood and her action.

This painting is a kind of summary of all the others. Though I have reservations about it, the picture represents a condensation of my many feelings about this particular subject. I still see many ways of improving upon this statement: enlarging the size; exaggerating some of the gestures even more; changing a color or two; even casting the head into more of the darkness. What's finally happened is that purely esthetic values have taken over: its effectiveness now depends more on purely formal, *pictorial* elements, rather than on literal accuracy.

Fatigue Factor

In this painting, as in much of my work, I must admit that I reached a fatigue point before the picture was actually done. The painting seemed to go stale on the easel. I found rendering a chore, and I was convinced that the whole task was virtually meaningless. Here is the most difficult point in picture making, when energy flags and spontaneity has all but disappeared. Leaving one painting to take up another has been the most successful way I've been able to deal with this problem. Unfortunately, I don't always have the luxury of time to wait out a return of energy; perhaps too many paintings leave the studio with features that I consider unresolved.

Of course, *having* the time to repaint can be a problem too. Degas, for example, was notorious for wanting to change or correct work that had long been sold. There are marvelous anecdotes of patrons having to break into his studio to retrieve their pictures, only to discover them completely repainted.

There are many artists who work in a much more sustained and deliberate fashion than I do. In some sense, I envy this quality. I'm restless and I have a shorter fuse. But I guess this is an important characteristic of the way I function—and possibly adds its own flavor to my pictures.

Why Paint at All?

By now, it must be clear that I don't find painting easy. So why do it? What "practical" use is painting to the artist or to anyone else?

The odd thing is that art does play a central role in the practical world. In expressing *himself*, the artist allows others to experience feelings or states of mind that can *only* be shared effectively through the painted image. For example, the Bible is an extraordinary and self-sufficient work of art in itself. The Bible evokes powerful feelings. Nevertheless, for more than 500 years, the church employed painters to convey the spiritual and mystical qualities in the religious experience that only art could capture. And everyone who takes up a brush performs a similar kind of communicative function.

On the other hand, it's also important to know that you can't be "profound" or "creative" every time you go to the easel. Some ideas—most ideas, in fact—aren't terribly "profound" or "important." But just being *any* kind of realist painter in the twentieth century is a great act of courage. The great realist art of the past is a terrible burden on the realist painter. Nor do we share the great spiritual or historic symbols—the majestic mythology of classical literature or the Bible—that were essential in the creation of high art. It's very clear that much abstract painting came into being as a reaction to the oppressive challenge of those overwhelming museum collections. Even Picasso, one of the great synthesizers and innovators of the twentieth century, felt always challenged by masterpieces in the Louvre.

I'm also convinced that the more you learn about art—as well as about anything else—the more problematic your work becomes. Students come to my class with some degree of satisfaction with their work; they leave with their skills more advanced and their discontents more acute. There's no way out of the sheer, hard work involved in learning *how* and *what* you want to paint.

If I can finally pinpoint my struggle as an artist—and it's still going on—it's the constant attempt to discover exactly who I am and what I feel, and to say it with the most direct, powerful "voice" I can muster.

Woman in Red, 1966, oil on canvas, 18″ x 24″ (46 x 61 cm), private collection. The painting was made at a turning point in my development. Whereas the color is still very much a part of the warm palette I favored, the whole image is rendered in almost flat patterns, with very little detail anywhere. Also, the brushwork is more direct, as in *alla prima* painting, and less involved with scumbling, glazing, etc. It is one of the few frontal portraits I've done, and I think it has special immediacy because of it. It has a glaring "fault" in the left eye, and I'm not certain whether it was by accident or design. In any case, it gives the portrait a sudden jolt, as if a defect in character was suddenly made physically palpable.

Demonstrations

The captions to the demonstrations which follow are written in a form that might roughly be called an inner monologue which describes the process of thinking and feeling that I experience while working.

As for the demonstrations themselves, I must admit that I have some mixed feelings about the paintings—as I often do. Although a demonstration is an excellent teaching device, it's a difficult way to paint a picture. As a result, some of the paintings in this group aren't truly finished, although as demonstrations, I think they're complete.

I've done a portrait and a figure painting in each of the three media I've discussed so far—oil, pastel, and watercolor. The captions generally focus on the central objective or problem in each painting, though each caption has a slightly different emphasis. Some deal mainly with the conception, while others deal with questions of technique. The paintings themselves tend to be simple in design and small in scale, since I wanted to be able to finish these within a reasonable time and with a moderate hope of success. In all other respects, they're representative of the main body of my work and my painting methods.

Step 1. A nice *used* canvas with a partially completed figure underneath. I've turned it to the horizontal to minimize the intrusion of the old picture on the new one. Also scraped off a little of the heavier old paint in spots. Need to draw here first to get the placement of the figures right. Use Paynes gray. Thins down to a very nice consistency and value for drawing. Add Prussian blue for shadows under the chair. Now scumble in a raw sienna shape for what will become the second figure. Good to have that orange patch there from the first painting. Will work well as an underpainting for the head and torso of the sleeping figure. Light values of pinkish orange will make good optical grays in flesh. Now use the palette knife to "ladle" on sandy beach color. For now, I'll make it a grayish white. Just want to obscure the background. Need "bumpy" texture.

Step 2. Go right to the visual focus of the painting—the head and torso of the sleeping woman with sunlight bisecting the form. Paint in just the major definitions of the form: nose, cheek, eye. Now add red in the towel and a touch of green for the canvas sling to start the color relationships. Think about the overall color as it will affect all lights and darks. These are figures outdoors. I want the feeling of sun, without it being blatant or obtrusive.

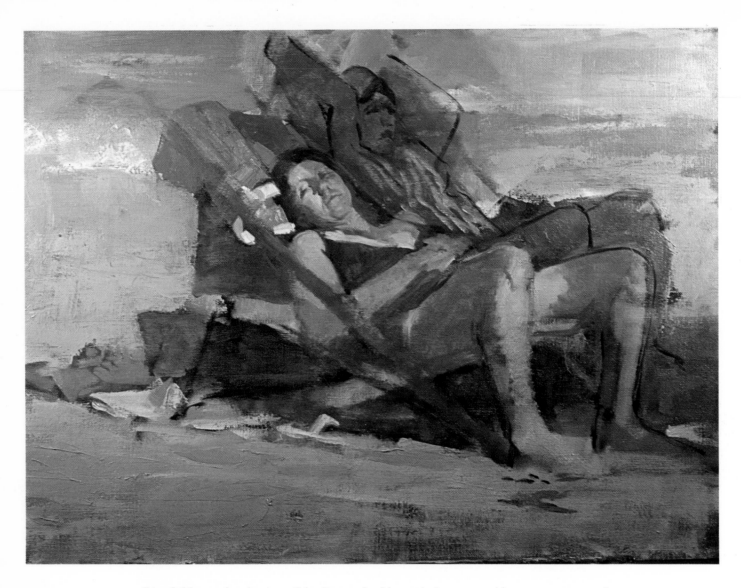

Step 3. Now paint the rest of the figure—bathing suit, legs, arm. Also suggest some of the beach equipment. For some reason these strike me as important. I want the cast shadow along this line to be fairly sharp, with the darks underneath the chair thinly painted and the sunstruck sand heavily scumbled and grainy. Now a light outline drawing for the second figure so I won't forget her. Add more pale gray to the sandy areas. Stop for a minute. Shall I warm up the sand for a feeling of sun? The local color of the sand was gray as I saw it on this particular beach, so shall I keep it relatively cool? I'm beginning to favor a Naples yellowish color.

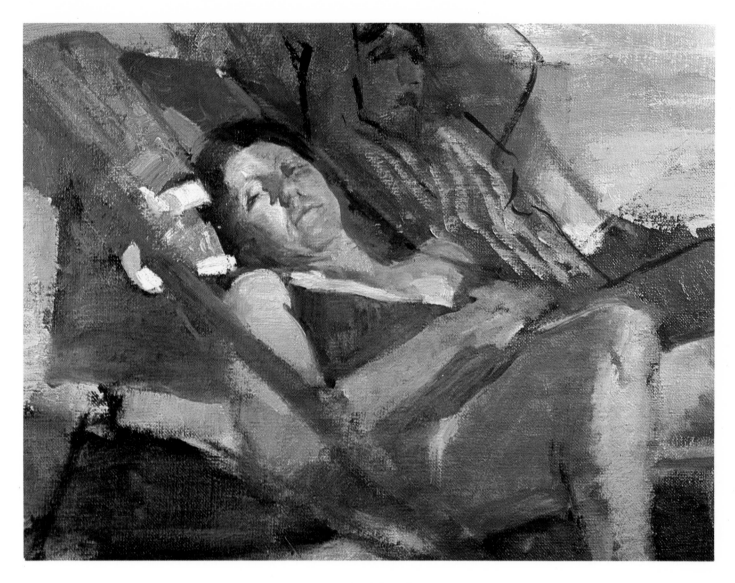

Detail of Step 3.

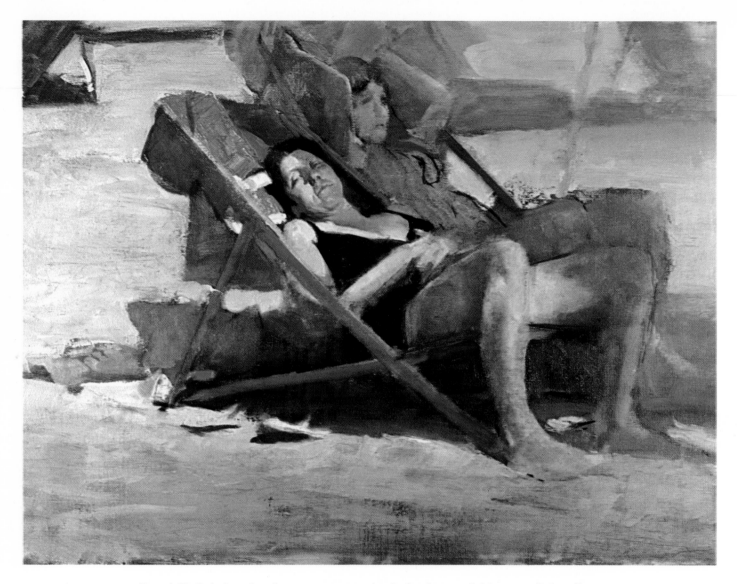

Step 4. Definitely going for a warmer tone in the background. Means a slight adjustment in the flesh colors. Also decide to eliminate the water and make it beach throughout. I think it will make the painting simpler and more cohesive. Okay, now get more detail in the sandals, the chair, the red towel, and the sleeping woman. The second woman too. Can't leave her dangling forever. She's in shadow, but also serves as a dark "frame" for the first figure—colors should be muted, with the modeling very subtle and low-keyed. Now suggest background forms: beach chairs and the cast shadows of unseen umbrellas.

Detail of Step 4. Work on the front leg here. It's a little too bowed. Scumble in changes as well as modeling. Optical grays work nicely. Strokes just catch the tops of the canvas grain, and the underpaint grays the form and establishes its volume.

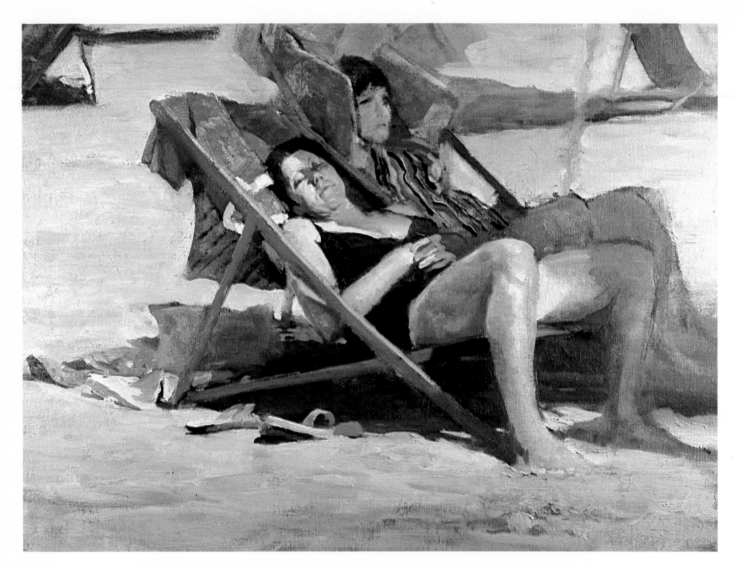

Step 5. Let's get on with it! I'm getting down to a "dry" stage where I'm doing more rendering than inventing. Second figure needs a pattern in the blouse, more definition in the face. Back to the sleeping figure for details of the hands and more form in the arms and elbow. Her leg still isn't done, but I can wait until the legs of the second woman are decided.

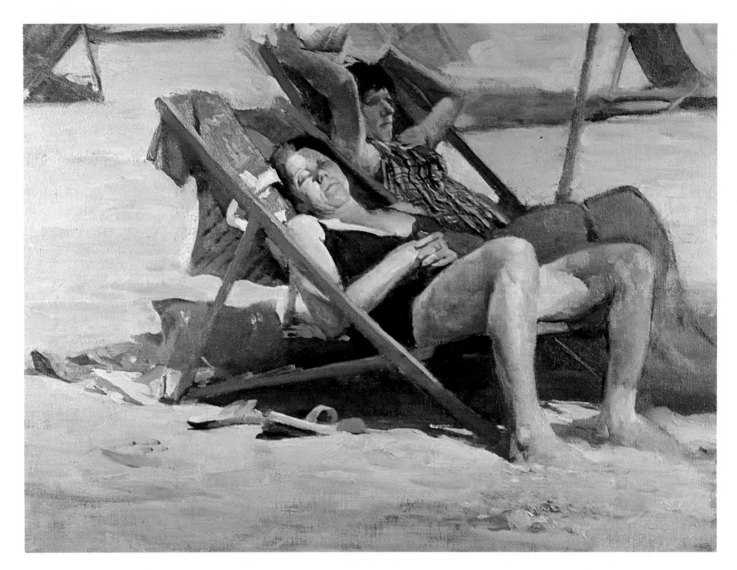

Step 6. Have added touches all over. More paint in the faces. Juicier, fuller feeling. The woman seems unattractive, yet I find satisfaction in the truth of this, plus the suggestion of languor or sun-inspired sensuousness.

Detail of Step 6.

Finished Painting. Dreaming of Fuseli, oil on canvas, 18″ x 24″ (46 x 61cm). Finish on background chairs and cast shadows seems inconclusive. The rest of the image—the second woman especially—while somewhat acceptable still feels "rubbery." Have changed the color of the striped blouse. This works better. But I think the painting needs more work still. Second thoughts about background. I think I prefer the water's edge, as in the first three steps. It's a simple shape. Divides the top third of the painting and gives a strong horizontal thrust to the chairs and figures. The beach chairs in the background are too spotty and distracting. Finally, I may have to beef up the color of the sand. Too gray.

Step 1. Going to try something a little different here—paint directly on white ground with no underpainting or tinted ground. I got the image—a self-portrait—from seeing my reflection in a darkened store window. Something about the combination of the white hooded raincoat and black captain's hat stirred the latent romanticism in me. But I visualized the image set in the studio with its white walls and gray shadows. So now I put it all down directly in paint. I don't need preliminary drawings for this one. Though it seems like an *alla prima* approach, I'll be scumbling and glazing between steps. The rectilinear forms of the studio contrast well with the curvilinear shapes of the hat, hood, and head. Using the palette knife for the coat will make it bulky and "meaty" as soon as possible.

Step 2. It's going quickly now after the simple suggestion of face and hat have been put in with broad, flat color areas. I can articulate the features with a few grays under the nose and eyes. There's a light problem—the mirror is diffusing overhead light and dark patterns by reflecting light back at me. Solve the problem by reversing the whole arrangement and placing the mirror against the light source (the window and the sky-light). The hat's too big. Redraw it by painting grays around it. Keep the darks under the hat beak and on the left side of the face warm. Lightstruck areas will be cool pinks and grays—mostly Venetian red and white.

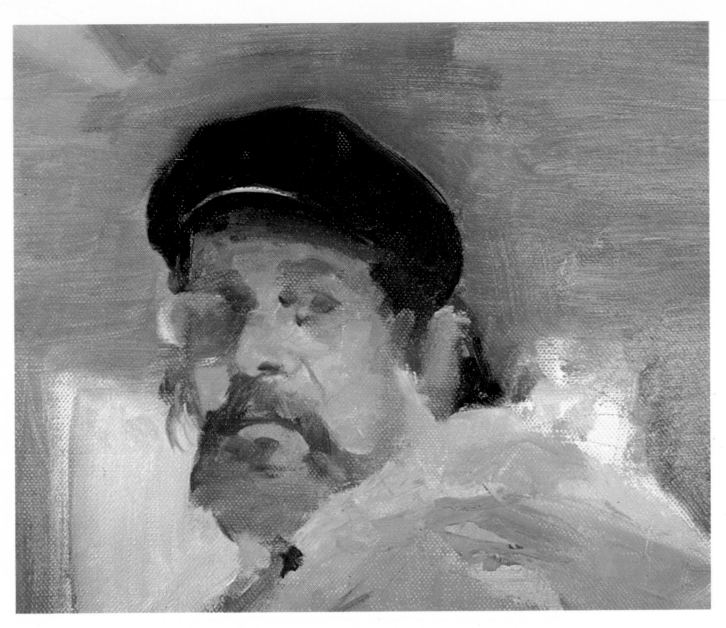

Detail of Step 2. The beard and hair are a simple pattern for now. The color of the beard is a middle gray; the hair's black and runs into the cap as a single form. The paint's getting very wet and slippery now. Have to stop. Almost tempted to leave the painting at this point. It has an immediacy and simplicity that's very appealing. But the expression's wrong, and the paint is really too thin.

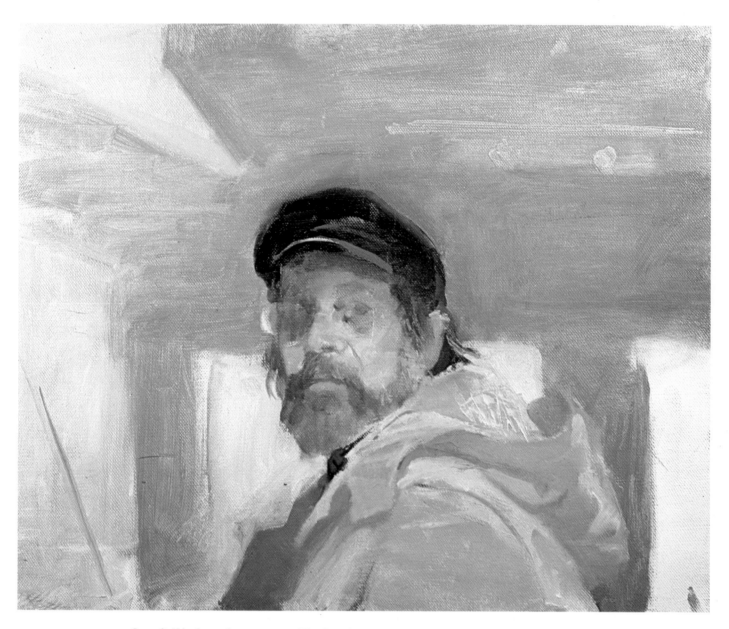

Step 3. Work on the coat now. The hood and collar need definition. Get cool lights on the top of the forms. Also change the shape of the beard and the edge where it intersects with the coat. Use some staccato dark grays and touches of black. The body line on the left side of the head needs strengthening. Make the sweater turtleneck—just a touch and barely visible. Let the background go for a while. Articulate the head first and then bring the rest into line. I like the shapes in the background, but I don't like painting hard-edge forms. I put it off.

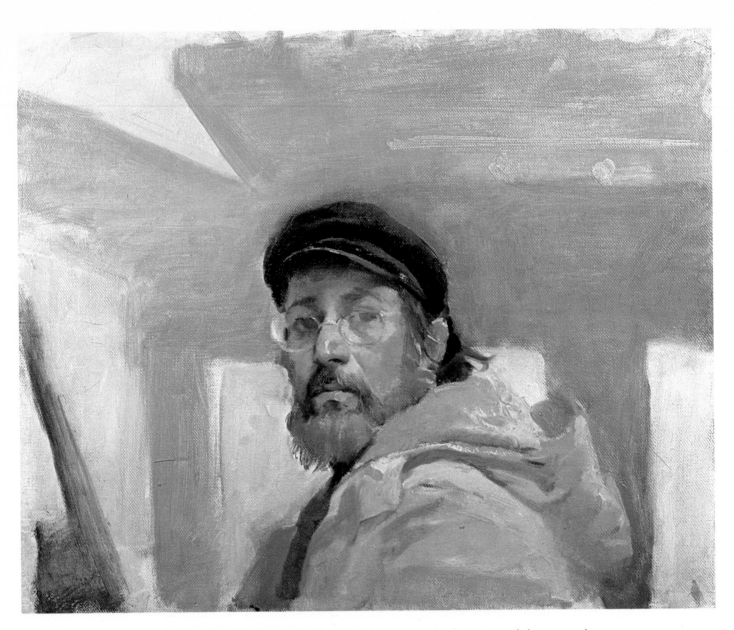

Step 4. Now the painting's ready for more detail. Get the features and the expression right. The nose needs help and tact. Redraw the nostril and drag some reds into the tip. Add darks underneath. It's getting there. Now the eyes. Keep the pupils lighter than in reality. Don't want to punch "holes" in the eyes. Want them to be gazing, but not harsh. Keep all the darker values lighter than they are—under the cap, the eye sockets, the nose, etc. Keep the forms open as long as possible. Just articulate the ends of forms—like the edge of the glasses, strands of beard and hair, the brim of the hat. The light squares in the background need definition. Should they be warm white to contrast with the cools nearby and elsewhere? It's getting very close to a finish. Let the new image settle. See if it's working as strongly as the first lay-in. Does the coat have too much detail?

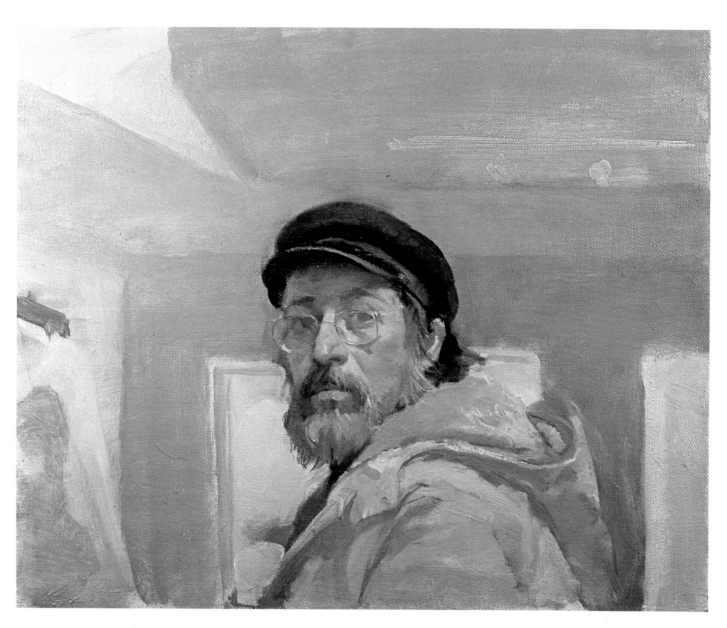

Step 5. Now clean up the background, especially the dimly seen painting on the left.
It's a mirror image of the painting I'm doing. That's fun. Third level of time and space.

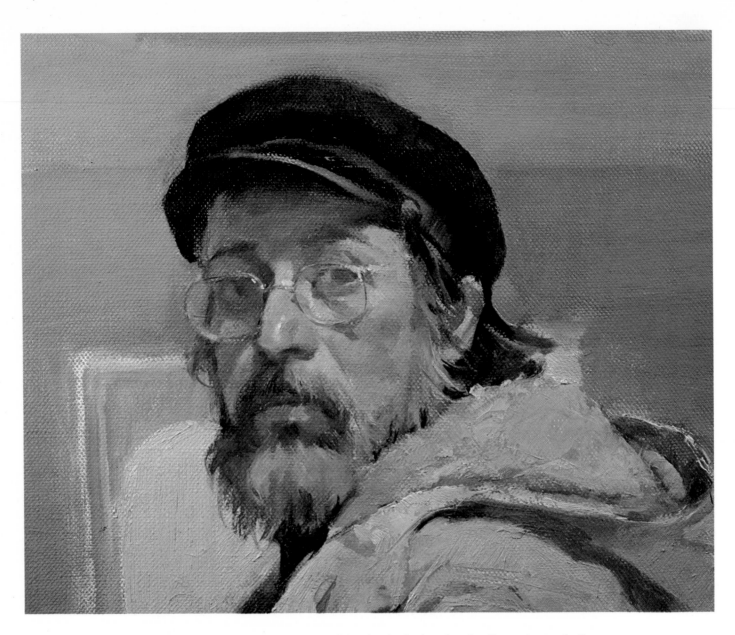

Detail of Step 5. The coat needs simplification in the hood and collar and more bulk to the paint. It's an almost white shape and needs weight to support the head. The nose is still too "nice"—get it bumpier. Just adjust the drawing on the dark side of the face around the contour of the nose and top of the bridge. The paint feels good. It drags when I want it to and flows easily for a sharp line—like in the glasses. I like the expression. Just the right mixture of an inside and an outside look. Like a surprised daydream. More like observing and being observed. That's what a self-portrait is, really.

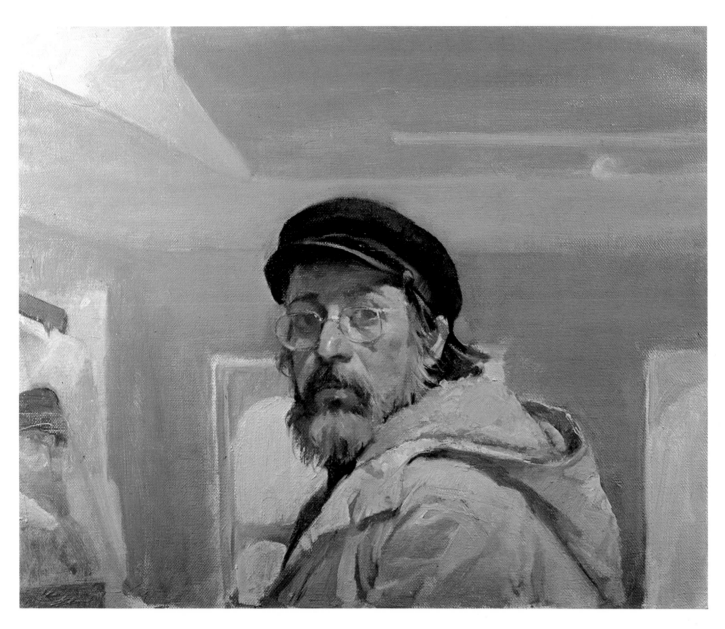

Finished Painting. The Greek Hat, oil on canvas, 16″ x 18″ (41 x 46 cm). I think it's finished. It's technically the "cleanest" painting I've done in a while. The paint is both thin and flexible in spots, yet it has impastolike buildups and a textured, meaty feeling in important places. Let it sit for a month or two out in the open. Then look again.

Step 1. The original watercolor sketch shows the model's head tilted up. I should try to maintain this.

Step 2. I picked a very smooth paper—an Arches cold pressed paper mounted on board. This may give me problems in adhesion later on, but I'll chance it. Can compensate for lack of tooth by painting both ground color and the initial drawing with a turpentine wash. Sized the board first with a 50% solution of shellac and alcohol. Won't wait for the turp to dry, but will paint directly into the wet turpentine with the pastel chalks.

Step 3. My dominant interest here is in the drama of light on the right side of the head—an unusual interest for me, since I usually find backlighting of this kind false. A second problem is sustaining the strong features and unusual look of this woman. Finally, I have to work this against the drapery with its bold, strongly colored background. A lot of forces to keep in balance. For now, just block in the large, simple shapes of light and dark modeling on the head, a bare suggestion of color and pattern in the drapery, and some scratchy suggestions of the sweater and T-shirt. Keep the forms simple and exaggerated. Pastel can go too "pretty," especially with this pose. Make the colors on the face cool (pinks and grays), except for a warm flood of light on the cheek and the forehead.

Step 4. I've made a big jump here. The patterns of the draperies are more sharply done, and the head is beginning to take final shape. I've articulated the features by adding warm ochres and sienna darks in the eye sockets, around the nose, and at the side of the face where the transition from light to dark is more acutely defined. This defines the structure of the cheek, the jaw, and the neck muscles more effectively. Should spray more frequently. The surface is going mushy. Not sure yet about that pattern of white on the right side or the picture on the wall.

Step 5. The pose has changed a bit—not critically, but enough to modify the feeling of the figure from one of strained formality to something a little more relaxed and un-selfconscious. Worked hard to get the features accurate, yet subtle. This is difficult because they're mainly on the dark side of the form. Have added pink earth strokes around the nose and kept the mouth redder than usual. Also outlined the eyes. The eyeliner, which I usually would ignore, works here to exaggerate the reflective look in the eyes. It also allows me to play with some linear shapes in an otherwise line-free, smoothly modeled form. Work on the sweater and T-shirt is also advanced, but there are too many creases and breaks. Must make it simpler.

Finished Painting. Patterns, pastel on Arches rag board, 20″ x 30″ (51 x 76 cm). The white, thin shape on the right, intended as a window with light coming through it, was all wrong. So was the picture on the left. I've eliminated these and made the background work as a simple, flat plane. Also sharpened the drawing and light on the shoulder and arm and eliminated these drawing lines. Am still worried about the split background, but I think that making it all pattern would somehow be wrong. Looking back at the original watercolor sketch also troubles me. I've lost something of the murky, troubled look that the sketch caught. Better leave this for a second hard look at some later time.

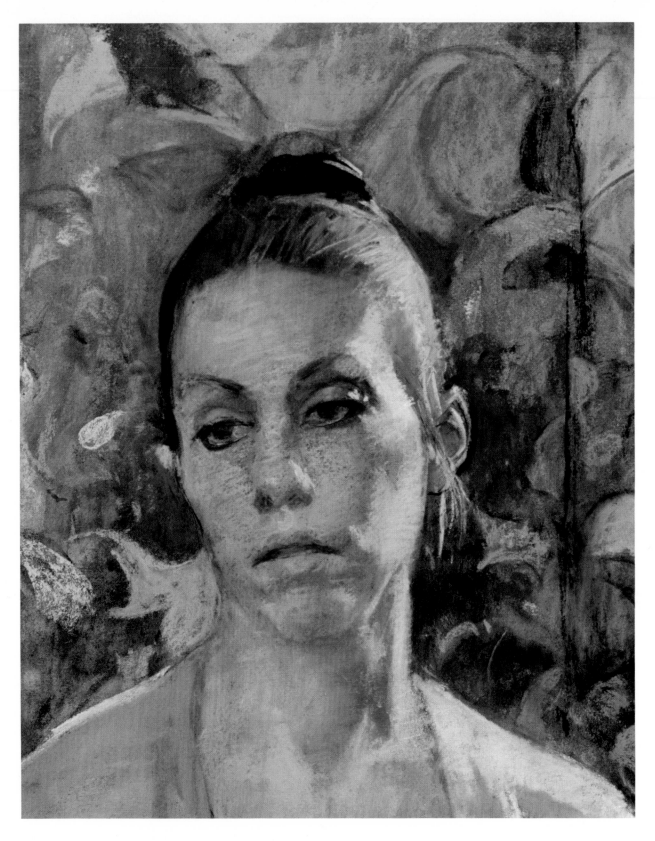

Detail of Finished Painting. I've added more accents to the features and beefed up the modeling of the ear and right cheek.

DEMONSTRATION FOUR: PORTRAIT IN PASTEL

Step 1. Paper has a nice rough tooth, which I need for this relatively large pastel with a wide variety of textures in the hair, boots, shoes, and floor. Paper has a crease running through the middle from being stored poorly. But I can remedy this by ironing the crease on the reverse side and then filling in broken fibers with acrylic gesso. Pastel chalks will fill out the rest. Arrived at the pose from a smaller pastel study, some photographs of slightly different poses, and some small compositional pastel pencil drawings. Want to characterize the complexity of an active personality in a passive pose, energy mixed with lassitude, and straightforwardness shaded by ambivalence. Start with broad turpentine oil wash. It will cover the large surface and give me an immediate value range. The first drawing has substantial weight. It can almost stand alone.

Step 2. Color is now overall warm greens and blues, with accents of brown and ochre in the books, floor, and boots. Start by scumbling in the colors for the coat, the skirt, and some background touches. No real modeling with pastels at this point. Add warm grays to the background and greens to the jacket. Doubt growing about the total cast of colors. I've an itch to go cool. Keep working nevertheless. Strokes of pastel chalk run every which way, but they're not important yet. Ultimately they'll cancel out to a uniform texture—a combination of vertical and horizontal strokes.

Step 3. Now start to work on the head, the hand, and the upper torso. Change the tilt of the head from the original drawing—too uncertain, too querulous. The light and character of the head are very important as usual. They define the form and feeling and set the psychology of the pose. Hair framing the head also has to be right—not too much activity or detail, yet enough to imply slight disorderliness or impulsiveness. Features so far are weak. Getting bad vibes. Picture feels stiff.

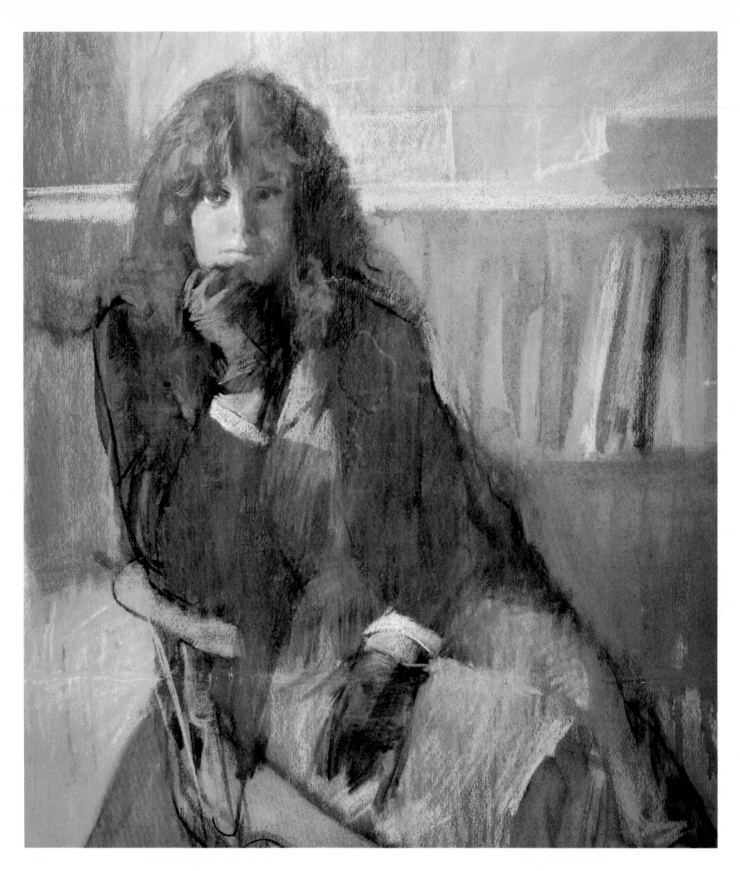

Detail of Step 3. The surface still isn't pleasant. Texture of the paper feels too intrusive. Pastels aren't working yet in their accustomed paintlike way. The mouth has an unintended smirk; nose is flaccid; eyes are out of line.

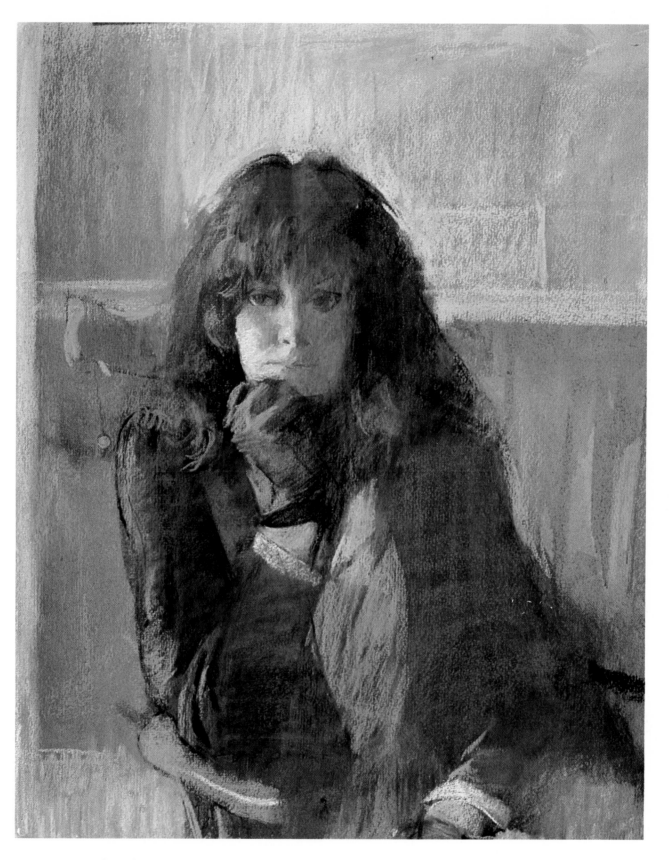

Step 4. Detail. Need to do some corrective work now. Am going to go warm—repaint the jacket brown so that it flows into the hair and forms a continuous shape to surround the head. This will be broken by the pink blouse and the cool pinks of the face. Start building more structure and character to the face. Draw in the forms with soft vine charcoal, then spray and break the line with vertical or horizontal strokes of color, depending on the kind of form to be rendered. Have beefed up background with more color. The picture still feels static.

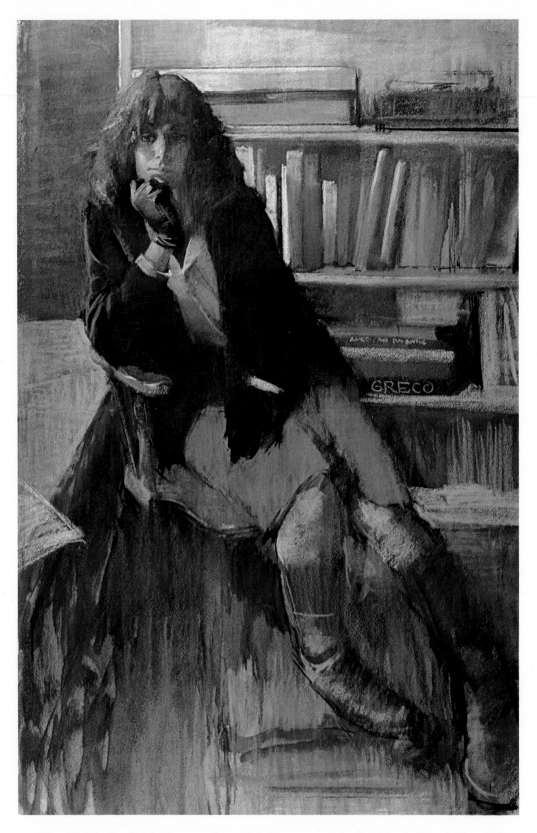

The Visitor (unfinished), pastel on Fabriano paper sized with shellac, 24″ x 40″ (61 x 102 cm). Reverse myself once more and go back to a cool palette. Decision based partly on the color of the skirt and the cool walls. (This turns out to be a wrong decision because I was focusing too much on the small portion of the image shown in Step 4.) Summon reserves of energy and work on the books to provide an interesting pattern, but the work seems unrewarding. Drop this and go back to the figure and work on the skirt and legs to get solidity and movement. Need to develop the head further, with touches of color and light around the mouth, chin, and nose. It's better, but something about the whole piece bothers me. From the beginning there was some impediment to a fluid evolution of form and content. I abandon this picture primarily because it seems dull and even repetitious. Despite all the preparatory work, there was a failure of conception and imagination.

Step 1. The drawing here was made from memory. I put my little daughter to sleep daily, and there's a mirror in her room. By looking into it, I check that she's asleep before I put her into the crib. The mirror also reflects the painted graphic on the walls of her room. This is just a quick charcoal rough. The paper is a little too smooth, but it's appropriate for the scale and simplicity of the image.

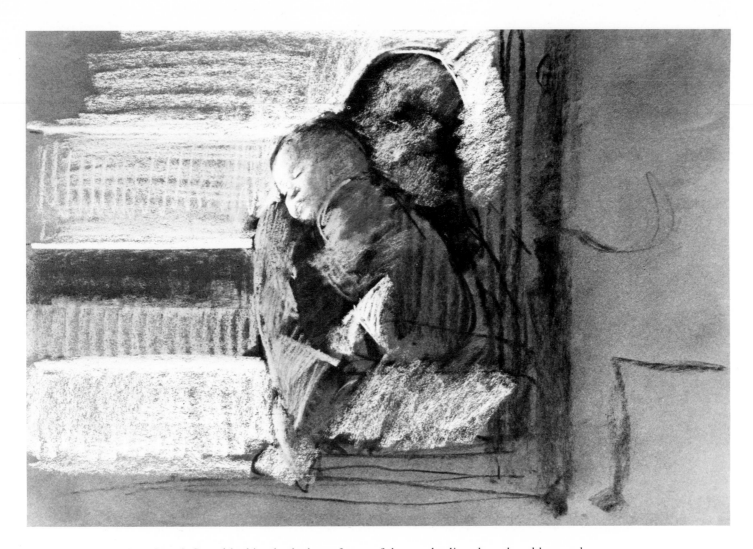

Step 2. Start blocking in the large forms of the two bodies, the ochre, blue, and green stripes of the graphic, and the frame of the mirror. Make a pencil drawing of Karen's head and body to fix the image more securely and use this to start detailing her face. Am a little uneasy. Not having a model or a comprehensive drawing makes me feel insecure. But there's a lot to do before that becomes a problem. I want the two figures almost fused together visually, with the only articulation coming at the faces and the edges of the form where light picks up a sharp focus. My head should be almost completely in shadow, with just a bit of light on my forehead and the tip of my nose. The strong colors of the graphic also have to be kept in check.

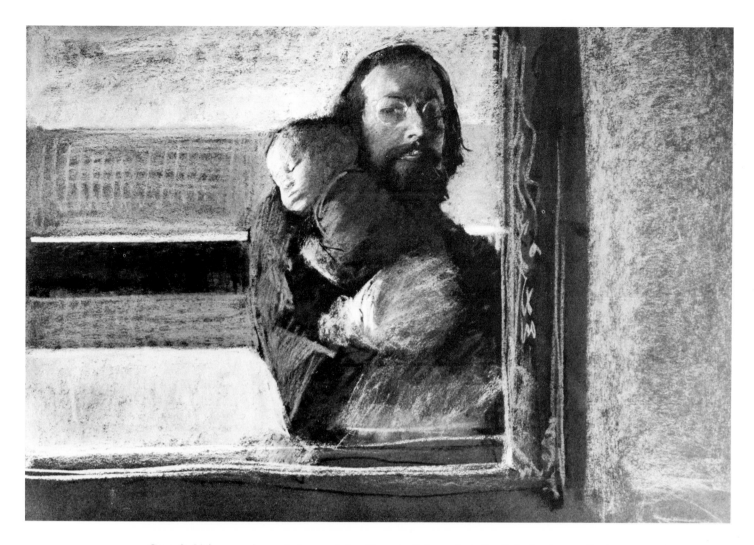

Step 3. Using a mirror, I do a mini-self-portrait here, but the light in the studio is wrong, and I feel I'm losing my grip on the idea. Work on the background, the mirror, and the adjacent wall. But the really important thing still eludes me. Too much of my head is showing. Karen is cuddling appropriately, but it doesn't work well as a form. The mirror seems to be getting in the way, and the colors of my shirt and hers are too dark.

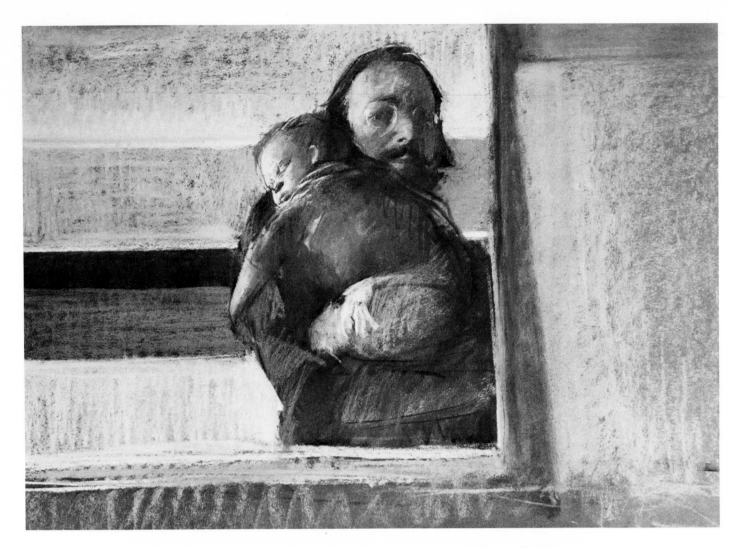

Step 4. Redraw Karen's body, cutting off more of my face and extending her arm out and across mine. Good! Now there's a break in that form which was relatively uninteresting. Also change the expression on my face and finally decide to remove the mirror frame. It's still not right—not all of it. I'll have my wife take a Polaroid snapshot of me holding the baby.

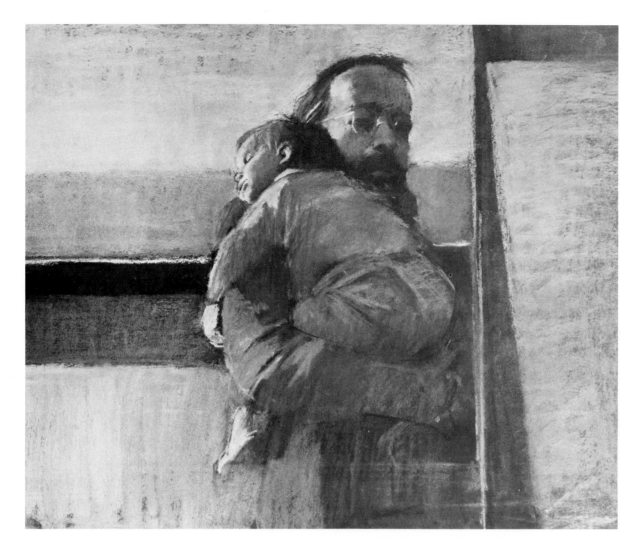

Step 5. I get the lean of the baby's body and her sense of trustful relaxation in sleep. Other changes needed. The composition is too cramped, so I remove the bottom line of the mirror and run the figure off the bottom of the sheet. I'm spraying a good deal because the paper is not holding up to the number of changes I'm making. I want only a small portion of my head showing, and I need a different angle to account for the baby's changed position. The darks are now scumbled in with gray, greens, and ochres. Just the side of my head is light—pinks and pale Naples yellow layered on successively. Color of Karen's clothes changed. I lighten my dark green shirt and add more layers of white, gray, and flesh ochre to the walls. This makes a stronger contrast, even though I've lightened the whole cast of the pastel. By now everything's greatly changed.

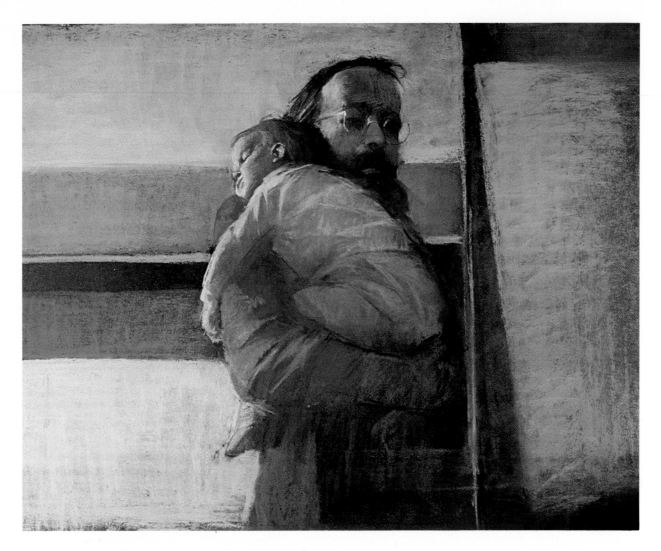

Finished Painting. The Baby's Room, pastel on brown Canson pastel paper, 15″ x 20″ (38 x 51 cm). From here on I'm pretty much home free. Sharpen the drawing on Karen's body—put in the simple few creases which will define her shape and show the character of the light. The same for her head. But leave the dark areas near my arm and at the edge of the mirror vague, with only the simplest modeling. Want it to show the reflection of the shape of the cast shadow just to the right of the mirror. I like the look of ambiguity in my face: a mixture of nurturing and what—resignation? Contrasts nicely with the baby's simple, trusting oblivion. Also like the way the surrounding shapes work—the cut-off figures, the graphic in the mirror, and the section at the top right of the painting. It all has a strong architectural quality broken only by the curved, interlocking forms of the baby and me.

Step 1. This was based on a photograph taken several years ago, but the subject had a rather unsuccessful history with the exception of a piece of relief sculpture I did about five years ago in Italy. I'm approaching this like a conventional watercolor, leaving whites open and working with pale washes at the outset. Also made a light pencil drawing beforehand.

Step 2. Focus here is on the woman straining forward, enveloped by revery (or pain?) in a sea of gray forms. The only movement I want is that suggested by the slightly swaying diagonal of the curtain, which also dramatizes the figure by silhouetting the head and shoulders. The "black hole"—the inside of the apartment—could be a problem, but it's essential in defining the thrust of her body. Add more color to her pink shirt, but leave the top of her shoulders almost white. Begin more modeling on the head and hands. Add cool gray washes to the dark side of the forms. These parts evolve very quickly. Now darken the triangular area behind the figure to help establish the darkest dark. At this juncture, the wash is a little more ragged than I'd like, but that will adjust itself as successive layers build. Am a little worried about the head.

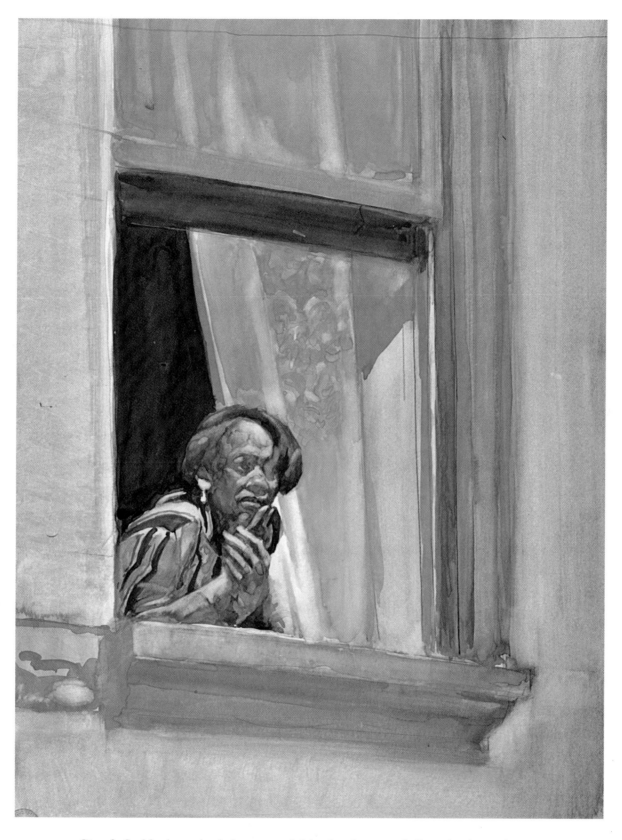

Step 3. Suddenly noticed that an awful lot has happened. I've wiped out the gray washes on the sides—almost back to the white paper, and added more purple-gray to the window frames. Then I really got into the figure. The head and features were defined by simple, flat washes wherever possible—even in the relatively small area of this form. Using a medium-sized brush, but one that loads up pretty well, I ran a lot of color into the face and body, remembering each time to layer the colors like translucent skins. I would alternately wipe out sections of the form to get back to the lights at the top of the forms, as seen in the forehead, the cheek, and the curtain. The little design of curls was pulled after a flat blue-gray tone was laid in and allowed to dry.

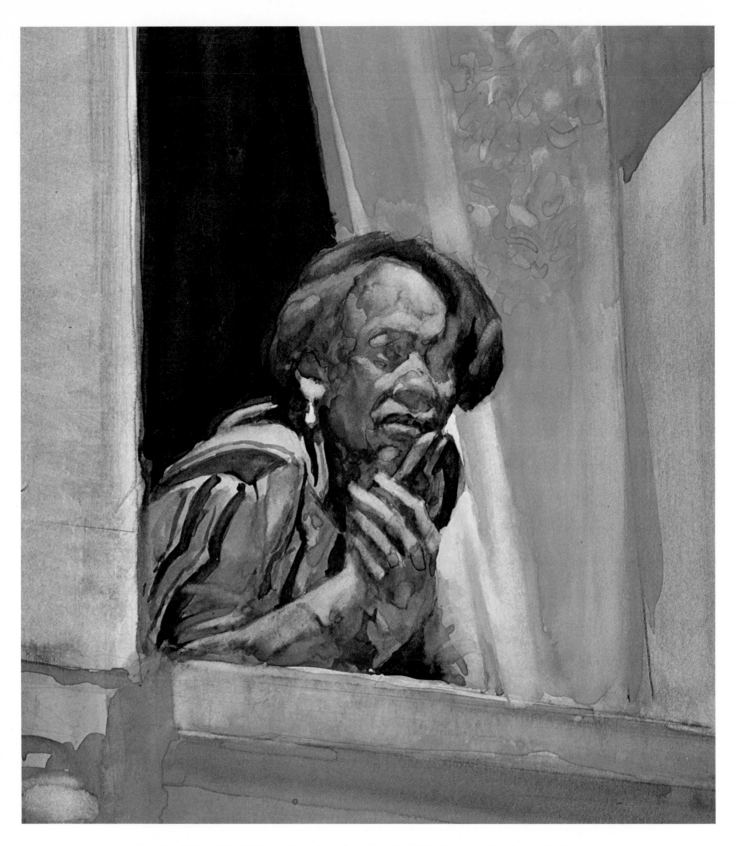

Detail of Step 3. I think this is going okay, but I still feel uncertain about the expression on the face and the solidity of the whole thing. All the little runs of washes have started to be counterproductive—to break the form into too many small puddles of definition. Also, that washy run from the hair into the eye on the right side is a bit too clever. The hair seems to work all right. I want it to just suggest frizziness without actually rendering it.

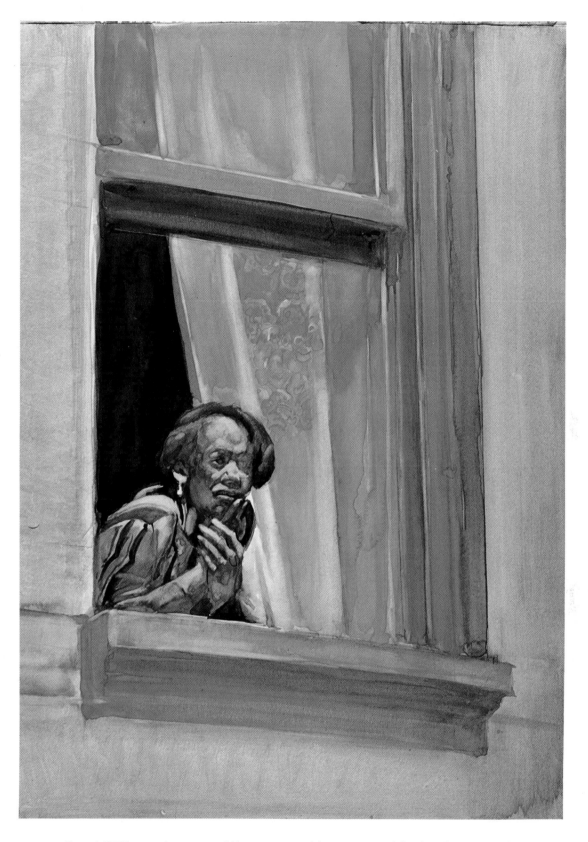

Step 4. Will try a shortcut—adding opaque whites to parts of the face for accents. No, this isn't any good. I'll have to wipe out a lot of it and start fresh. Hold off on this for a little while and get the frame of the window on the right-hand side sharper—I want the frame to be very mechanical and impersonal looking, even though its edges have actually been chipped and battered by use. But it should feel inert and lifeless without actually being rendered that way. This is tough. Words and feelings don't always mesh. I really don't like rendering these forms. Perhaps it shows.

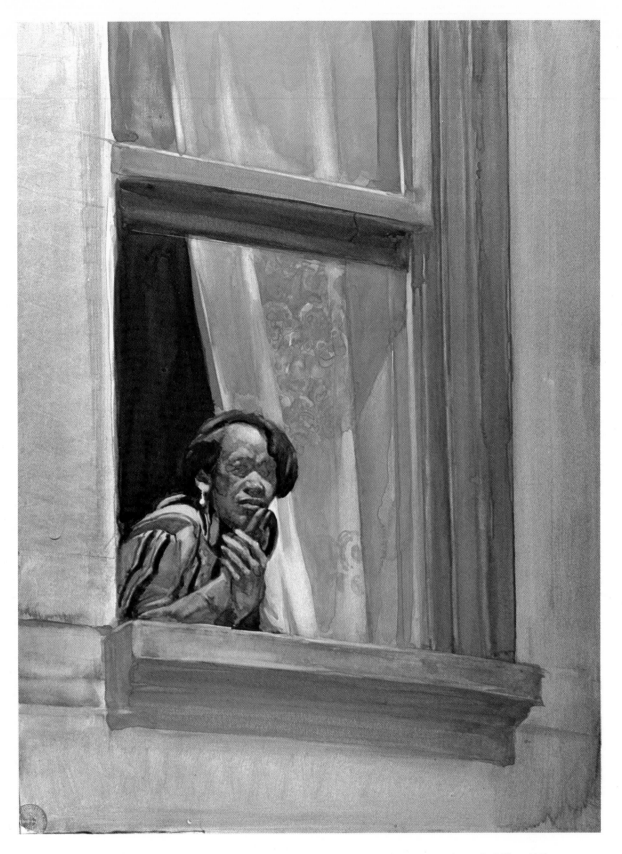

Finished Painting. Harlem Window, watercolor on Strathmore rag board, 15″ x 19″ (38 x 48 cm). Okay, I think the balance is right. Also the look on her face—thoughtful? worried? angry? smiling? As I look more at the painting. I feel a bit of a stranger to it, like "Did I do that?" I think I feel this partly because it seemed to go very quickly— about three or four sessions lasting about one and one-half hours each. I think I like it. But I'll probably do another version of it to explore another way of recreating the same moment by a different and perhaps more effective means.

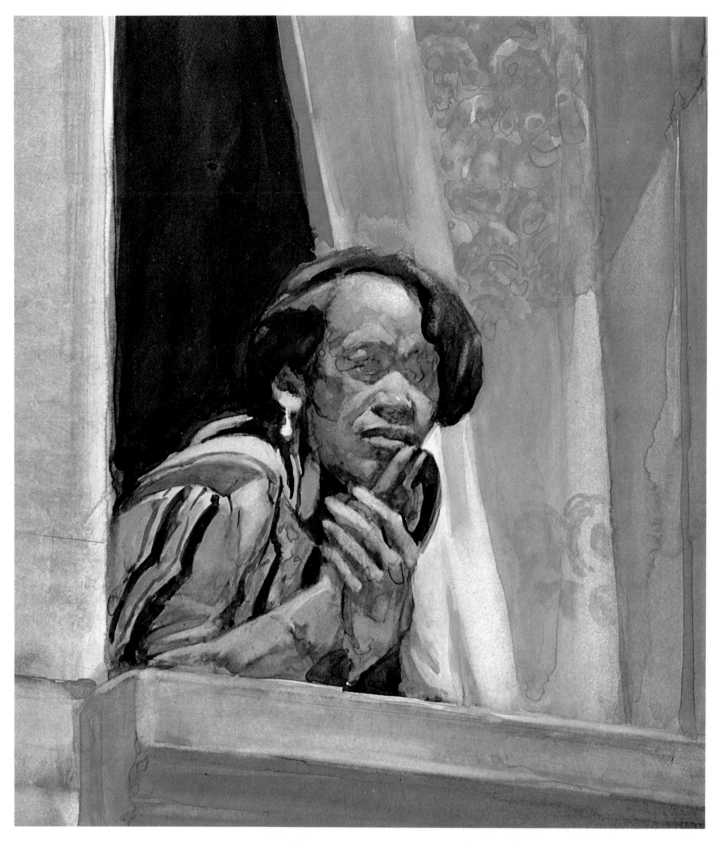

Detail of Finished Painting. Back to the head. Wipe out the lights on the top of the nose and under the eyes and forehead. Now add a single new ochre sienna wash to the dark side of the forms and some blue-grays in the eye sockets. Model the flat nose by picking out a single white highlight. Maybe that's a little too specific. The fingers get another touch of blue for reflected lights and some added accents. The hair? Yes, with additional changes in the face, window curtain, and frame, the hair needs more punch to bring back the silhouette.

Step 1. Am using the same model here as in Demonstration 4. Feel thwarted by my failure to bring off that picture. This time I'm clear about the dominant visual quality I want to get. It's actually a spinoff of the third stage of the pastel. The model came wrapped in a dark brown fur coat which seemed almost continuous with her hair. The combination of these textures with the pink-turned-red-from-the cold of her face triggered the visual stimulus. I apply a warm sienna and yellow ochre wash to the whole board and allow it to dry, but not completely. Now paint the figure directly without pencil drawing. Use almost all burnt umber or sepia for the hair and coat, but not for the face. Leave a lot of whites and fill out the form with earth-red blobs for the nose and mouth and some pinkish grays for the merest suggestion of eyes.

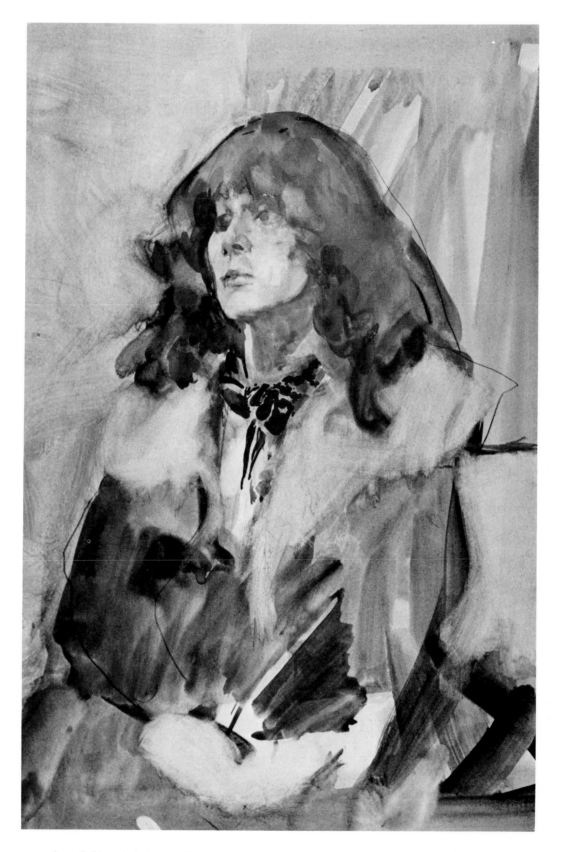

Step 2. Very briefy pencil in some corrective lines on the back of the head, the collar, and around the left arm. Her scarf is a pattern of rich blues, with touches of red and purple. Put that in for a strong color note almost immediately—will key against it. Wipe out more of the coat collar and put in some dark touches on the hair. Now add supplemental washes of grays with touches of ochre or sometimes ultramarine blue to the head, especially under the jawline and around the eye. Pick out some whites on the nose. Also around the wash in the eye socket to form the pupil of the eye. Now add accent of burnt sienna for the nostrils and the line between the lips to articulate the shape of the mouth. The structure of the face is still mushy, even though I've painted in many of the features.

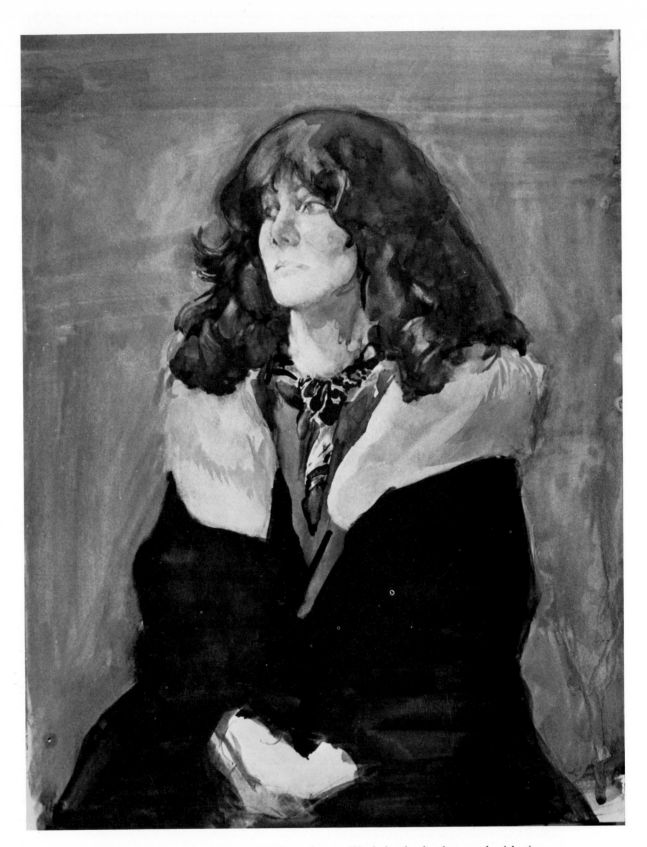

Step 3. Now put in all the subsidiary forms. Wash in the background with sienna touched with opaque whites and lay in a flat, simple shape for the brown coat. Focus on how to make the glint of myriad curls coherent. Most of the colors are now all warm—pale ochres on the collar, faded sienna in the background, raw sienna and umber for the hair, and sepia for the coat. Only the face and scarf are done in cool colors. Wipe out almost all of the features of the face, leaving only a slight tinted discoloration on the white surface. Let the paper dry quite thoroughly. Okay, now lay in fairly simple light washes for the cheek, nose, and lips. Float the color off the brush, with the color a little more watery than usual and the brush fairly heavily loaded. Pick out the lights on the top of the nose and at the crest of the cheek with either a damp brush which has lost its point or with a damp piece of paper toweling.

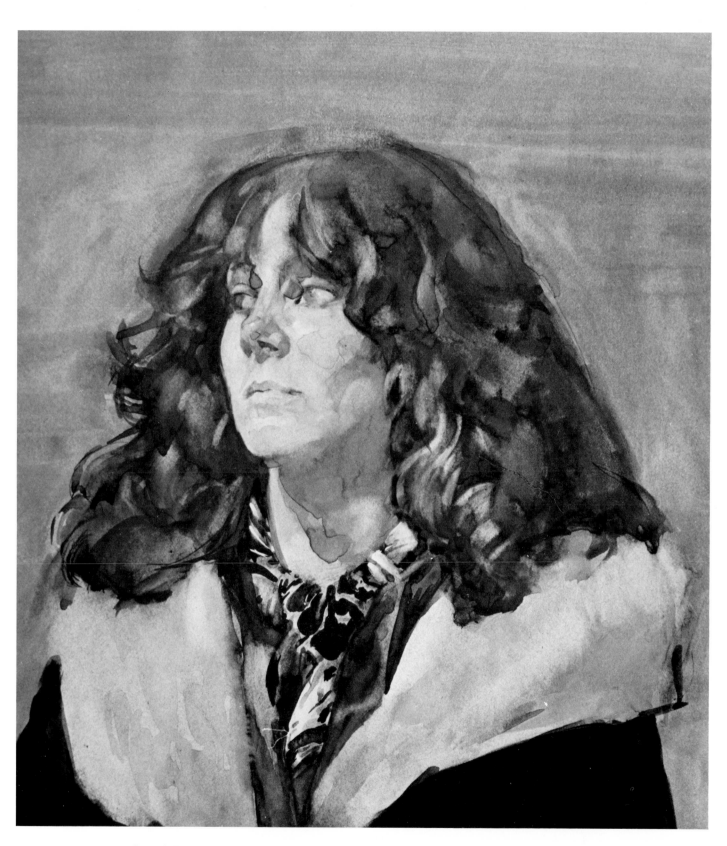

Step 4. Detail. It's time to zero in on the final image. With a brush I pick out more curls in the hair. Also correct the silhouette on the top of the head. Define the lips more clearly and add more body to the side of the face that's away from the light. This gives me a cheek and jawline. Expression's okay. It's turned away, yet looking. Must do something about the run of curls on the left. They're too blobby and linear. I've rubbed out a section of the hairline. It was a little too hooded before. Good. That's stronger. I like the look in her face—a certain air of expectancy.

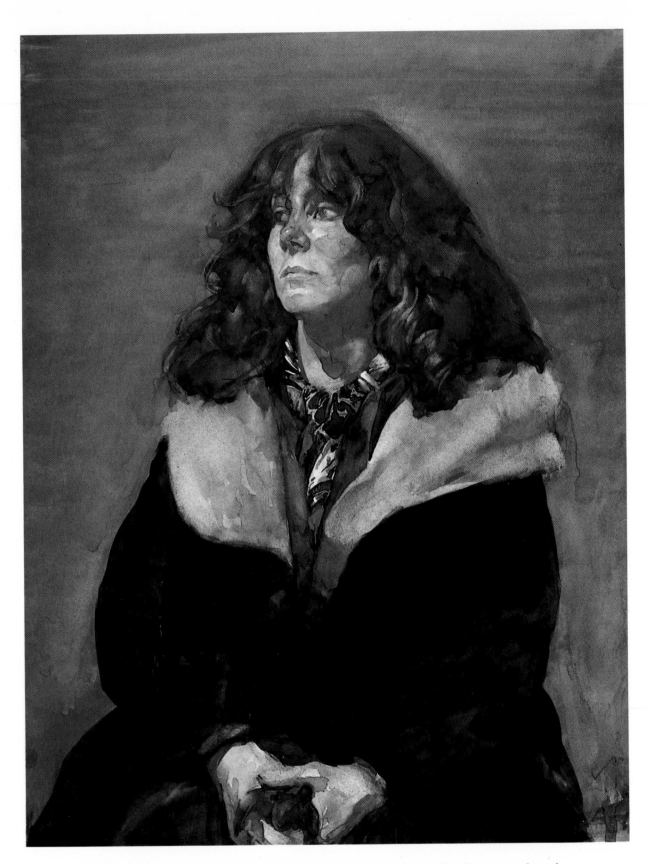

Finished Painting. Portrait of a Young Woman, watercolor on Strathmore rag board, 15″ x 20″ (38 x 51 cm). Pick out strands of hair on the left side, but be careful that it doesn't get mannered—too designed and mechanical. That leaves the hands clasped around a glove. Tricky here. I want it to read clearly, but with a minimum of rendering. Just some blobs of pinkish tints for knuckles and a touch or two of grays and ochres for the fingers and the dark side of the hand. Let the hair blur out and stay ragged rather than defining it more. That reinforces the more precise rendering of the other parts. Time to stop.

Color Gallery

The paintings selected for this section are a cross-section of my work over the last seventeen years. The selection was made with several criteria in mind. The quality of the painting was important to me, of course. But I also wanted to show varied subject matter and a variety of media. Hence, there are some pictures missing from this grouping that I'd like to have shown. But several were unavailable for photographing, while others were eliminated because of space limitations and the need to show specific subjects and techniques.

Nevertheless, I find this collection interesting because it does illustrate a central characteristic of my work—the exploration of a variety of forms and images to resolve a single theme. The collection also effectively summarizes the range of my painterly interests and reveals, quite unexpectedly, a persistent autobiographical thrust to much of it. One of the earliest paintings, The Family Circle, *and one of the latest,* The First Born, *are about the same thing.*

Pregnant Woman (above), 1972, oil on canvas, 24" x 29" (61 x 74 cm), courtesy FAR Gallery. Done from a drawing I made near the end of Claire's pregnancy, this is an attempt to suggest some of the conflict and anxiety that I think are part of every woman's feelings at this time. I painted this over an old canvas, and the picture went very easily. I think the warm colors here are an intuitive reaction to the idea of life being nurtured and brought into being. Yet the composition also suggests some of the tension that accompanied Claire's experience.

Claire (right), 1972, oil on canvas, 50" x 25" (127 x 64 cm), courtesy FAR Gallery. This painting was done just after the birth of our first child, Bobby. I think the portrait was my response to something in Claire that suggested a desire to reaffirm her identity as an individual and perhaps as a woman. Hence the stance, the open blouse with its active pattern, and the look in her face, which is highly ambivalent. The afro hairdo also underscores the volatility of her emotions at that time.

The First Born, 1975, oil on canvas, 45″ x 50″ (114 x 127 cm), courtesy Meredith Long & Co., Houston. This is a painting done several years after the moment depicted. The setting is our house in Italy and represents a recall of a simpler, more idyllic time. It was done from a photograph plus sketches and a pose or two from Claire. The canvas was a heavy-toothed linen that had been painted on before, then virtually skinned down with paint remover. I took pains to clean the surface thoroughly before using it. I think the gesture of the baby saves the painting from sentimentality.

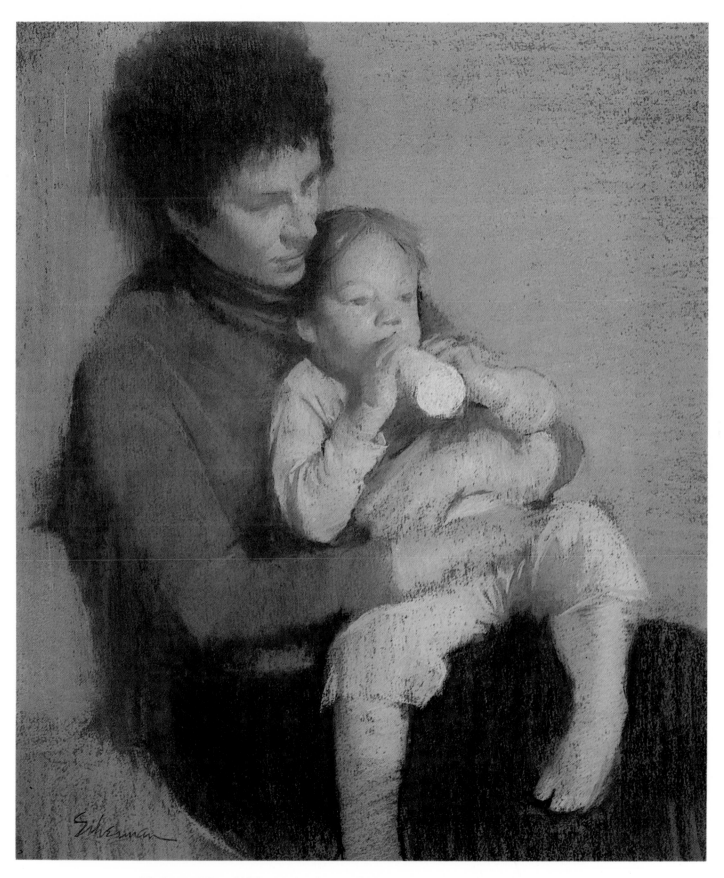

Mother and Son, 1976, pastel on brown Canson paper, 17″ x 19″ (43 x 46 cm), courtesy FAR Gallery. Like many of the pictures I've painted of this subject, I tried to balance the universal and the particular. This involved a choice about how specific the sitter is to be depicted and exactly the right note to be struck for the child's face. The pastels are used here with that in mind. The strokes are broad, flat, and almost without differentiation, except for those select areas around the head and under the arms of mother and son.

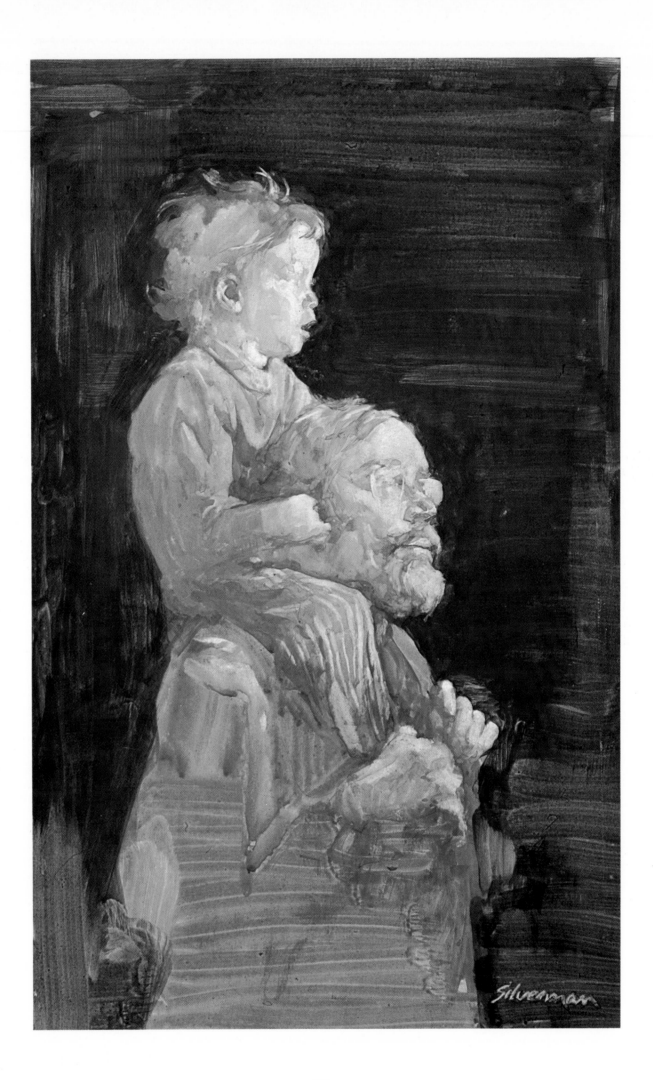

106

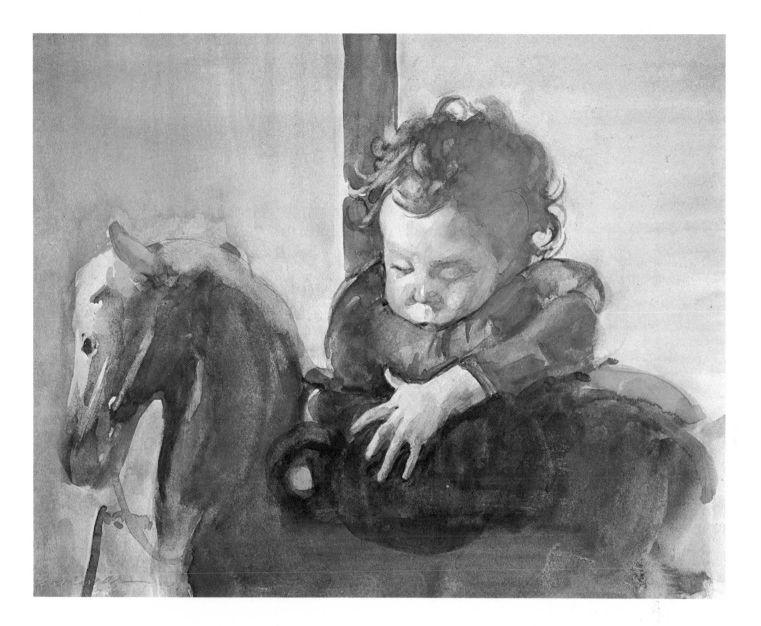

Rocking Horse (above), watercolor on rag board, 8½″ x 11″ (22 x 28 cm), collection Joan Catherine Preuhs. I became a father for the first time at a later age than most, which I suppose accounts in part for the great rush of feelings I experienced. These feelings found their way very much into my work. This painting was done from a photograph of Bobby when he was almost two years old, when he had long ceased to stay still at all except in sleep. I realized at this time that he had suddenly become a person. The pose was an unexpected one, but I seized on it immediately for the precocity of its content and the lyrical, but somewhat sad, imagery conveyed by the curve of the rocking horse and the boy hunched over it. The red stripe in the background was an arbitrary invention. The painting seemed to need something in that spot.

Bobby & Me (left), 1975, watercolor on clay-coated paper, 10½″ x 16½″ (27 x 42 cm), collection Dr. Martin Greenburg. I've done several paintings of myself with one of my children. I like the idea because it is often missing from the "literature" of art. The preponderance of pictures with children are about motherhood. Certainly the work of Mary Cassatt has forever united *mother* and child and, of course made the subject forbidding for anyone else to try. I think this pose is almost universal but a very special one to me. I painted it almost from memory, with an occasional reference to some sketches of Bobby in profile and a look in the mirror for a sometimes strained glimpse of myself. The watercolor on this surface moves very easily so that I kept the rendering to a minimum, especially in the lower section of the painting. The dark background was chosen to place it in a timeless context and for dramatic emphasis.

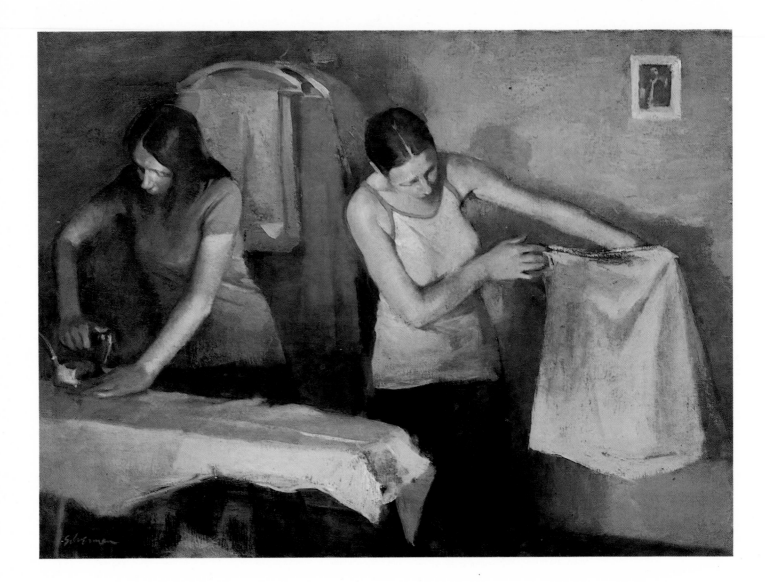

Two Laundry Workers (above), 1975, oil on canvas, courtesy FAR Gallery. This is part of a lifelong series devoted to the image of a woman ironing. I suspect the original feeling has been reinforced through seeing Degas' paintings of the same theme. But mere imitation cannot fully account for the hold it continues to have on my imagination. This painting was the last of a group done in Italy, where there was a laundry on virtually every corner, and people were eager to pose. It was made from the same model in two different poses drawn at different times.

Study for Laundress (right), 1975, watercolor on gesso-coated board, 13″ x 19″ (33 x 48 cm), courtesy FAR Gallery. Here again I used the same model, a young woman who seemed to embody the curious contradictions of this job—the body could sometimes assume a particularly graceful pose combined with an almost palpable sense of monotony.

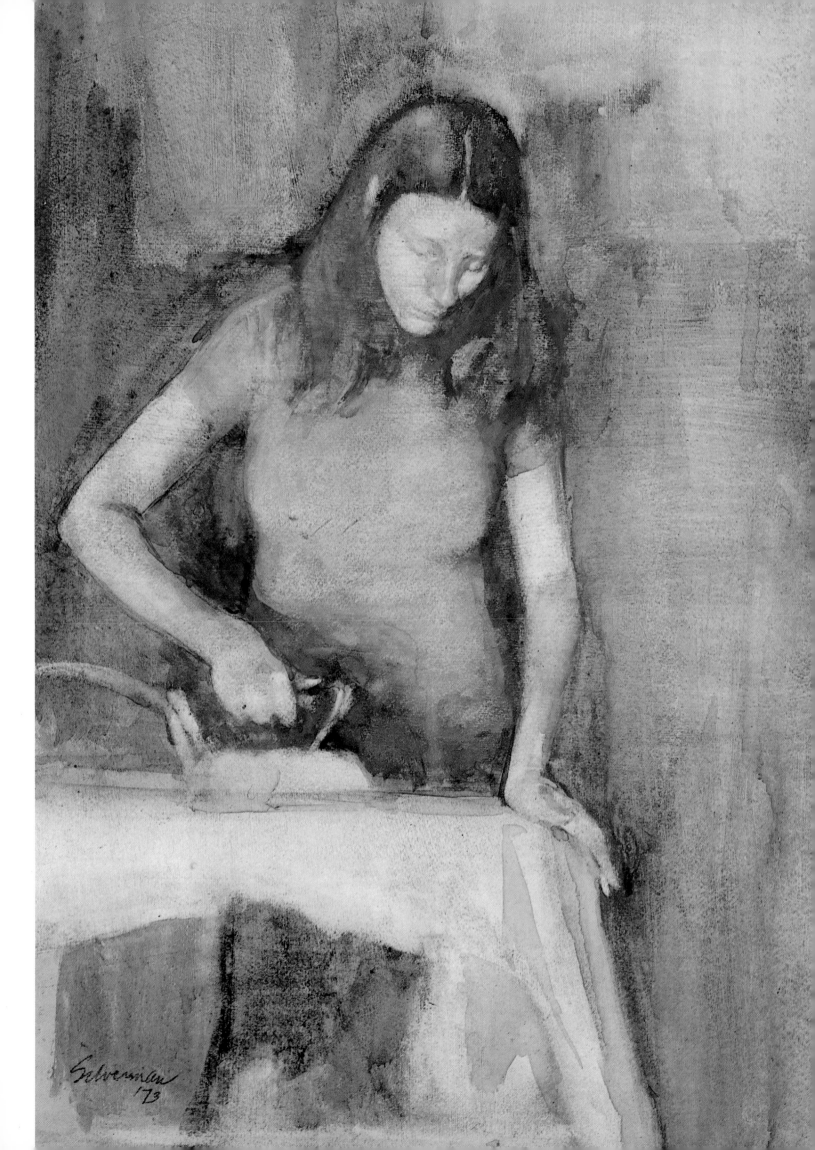

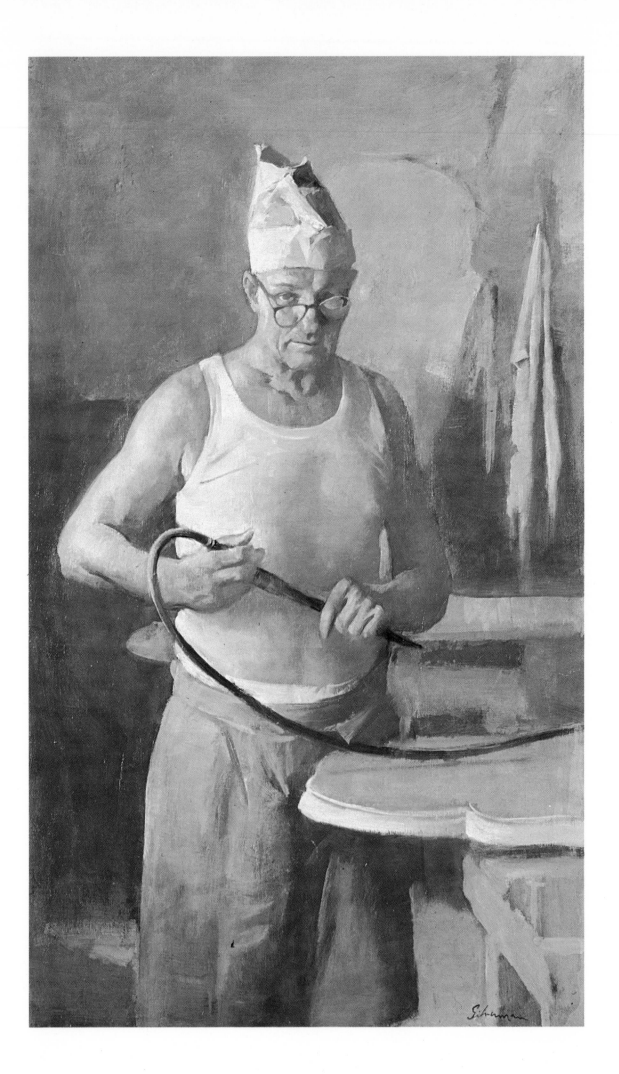

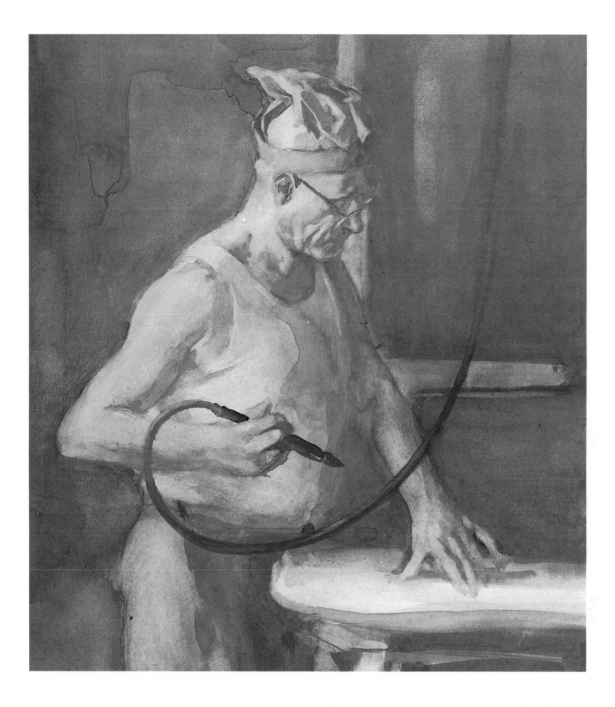

Study for Marble Cutter (above), 1974, watercolor on rag board, 10½″ x 6½″ (27 x 17 cm), private collection. This was one of several drawings and watercolors I did of this man. Before I settled on the gray and white colors of the oil (left) I tried other combinations of cool colors. Here he pauses in his work to test the surface of the stone for smoothness. The intensity and singlemindedness of his expression intrigued me, and the single linear curve of the powerline seemed to be a graphic echo of this concentration.

Marble Cutter (left), 1974, oil on canvas, 38″ x 32″ (97 x 56 cm), courtesy Meredith Long & Co., Houston. I was intrigued by this man whose only sense of poise lay in his skill at cutting and shaping marble. His world was white and gray, stones and dust. Yet there was something innocent in his simplicity. I painted this picture from a variety of studies and in almost monochrome values, with the exception of the face and body. The hat was made of folded newspaper and is traditional to these Italian workers.

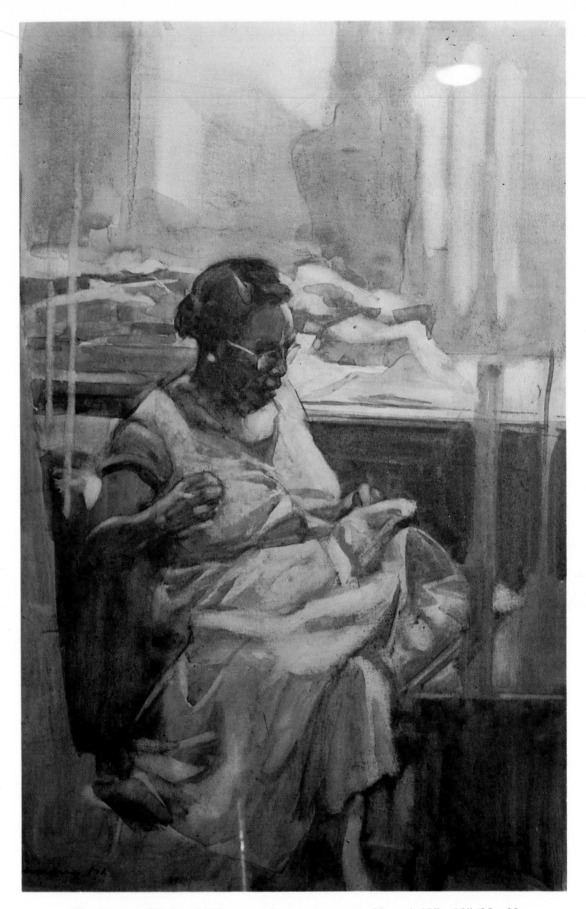

The Garment Worker, 1968, watercolor on gesso-coated board, 10″ x 15″ (25 x 38 cm), collection John Mortimer. Working from drawings and photos, this was also one of a number of studies that was aimed at a large painting of the piece workers in the garment industry in New York. This same pose was used later in an oil, but with the position reversed. The large painting never was completed, but like many other ideas, it lies waiting somewhere in my life for actualization.

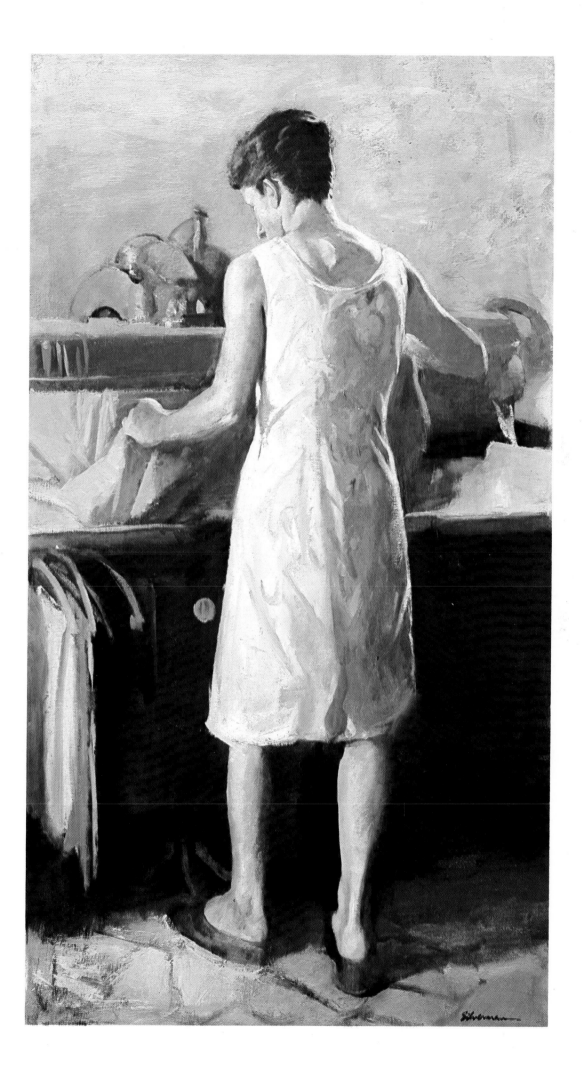

Nude (above), 1965, oil on textured paper board, 9″ x 12″ (23 x 33 cm). The contrast here is inescapable and telling. But I like this painting because it shares some of the characteristics of the pastel at left. However, here the young woman is turned inward, unaware of her body or much else. Perhaps this is a defense that all female models have in the face of revealing themselves to strangers. The painting was done from the model in one sitting.

Nude Model (left), 1967, pastel on Canson paper, 17″ x 22″ (43 x 56 cm). This and the picture above are a part of my work that I generally have ceased to do. Nevertheless, this pastel continues to hold my interest. The figure is not terribly well realized—there are problems with the drawing of the hands and a general laxness in the rendering. I think it's the face, with its completely uncharacteristic and even enigmatic smile, that redeems the pastel. The gestalt is one of an irreverence and abandon that is *almost* sexual. As such, it has life that emerges despite the difficulties of rendering or technique.

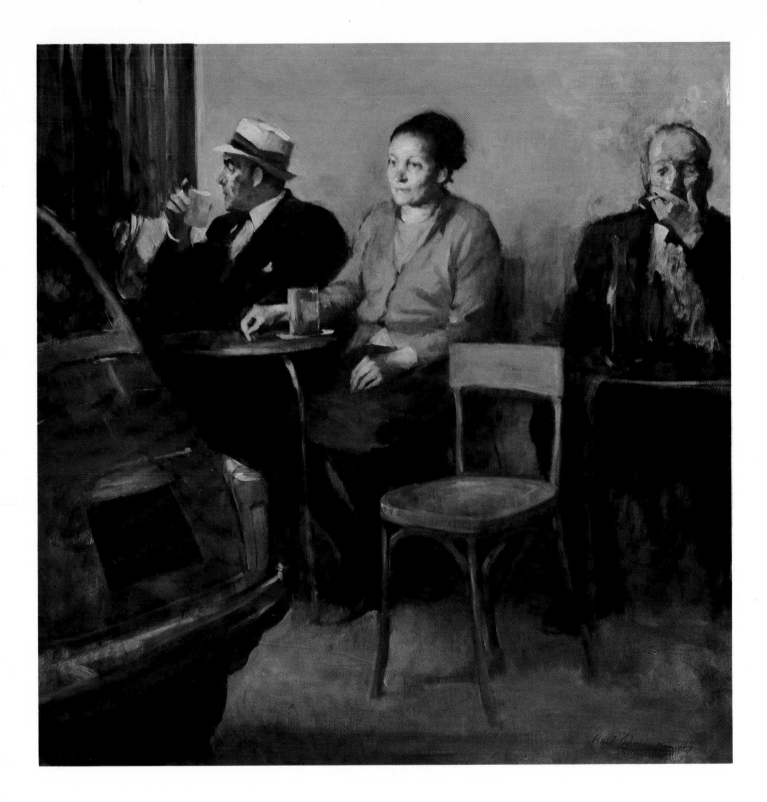

Fiat 500, 1966, oil on canvas, 35″ x 42″ (89 x 107 cm). This painting had its genesis in Rome during my stay there in 1965. It deals with a variety of notions: the way people relate in a social context without specific ground rules, the isolation of men and women, and the intrusive role of the omnipresent automobile. The painting has many irresolute passages, but it is still interesting to me, primarily because of the figure of the woman.

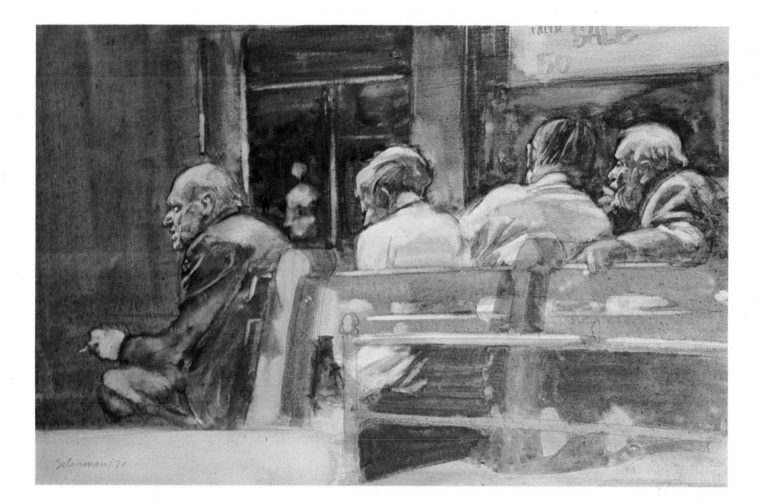

The Benchsitters, 1969, watercolor on gesso-coated paper, 11″ x 19″ (28 x 48 cm), private collection. This is one of a series of paintings that eventually appeared in *New York* magazine along with a text written by Claire, as a picture essay on the people who sit all day on the concrete island that divides upper Broadway. It is one of the few "illustrations" I've done that I think survives as art, primarily because it was self-initiated. The view here, from the rear of these people, was prompted by an interest in the problem of suggesting their life circumstances in an indirect fashion much like the intention in *The Pressers* on page 114. The watercolor was done quite rapidly from a photograph.

The Family Circle, 1960, oil on canvas, 45″ x 72″ (114 x 183 cm), collection David and Patsy Brandt. In one respect this painting is a summary of the period in which I was terribly influenced by Rembrandt (the adjective may be used either way). However it was also the first painting of this size that I was able to bring off with a degree of success. My intention was to use the boxes of the theater as a metaphor for society and to portray this group of people symbolically as well as realistically. Most of the people were close to me, and I posed everyone individually, using a spotlight on the floor to simulate the theater lights.

The Long Black Veil, 1965, oil on canvas, 32″ x 50″ (81 x 127 cm), collection The Anchorage Historical and Fine Arts Museum, Alaska. The title of this picture is from a lilting, sad folk song called "The Long Black Veil," sung by Joan Baez at the time this was painted. It is a painting that focuses on the active and passive personalities of the two women and the role of light as a dramatic agent in the relationship between them. The figures are close to life-size.

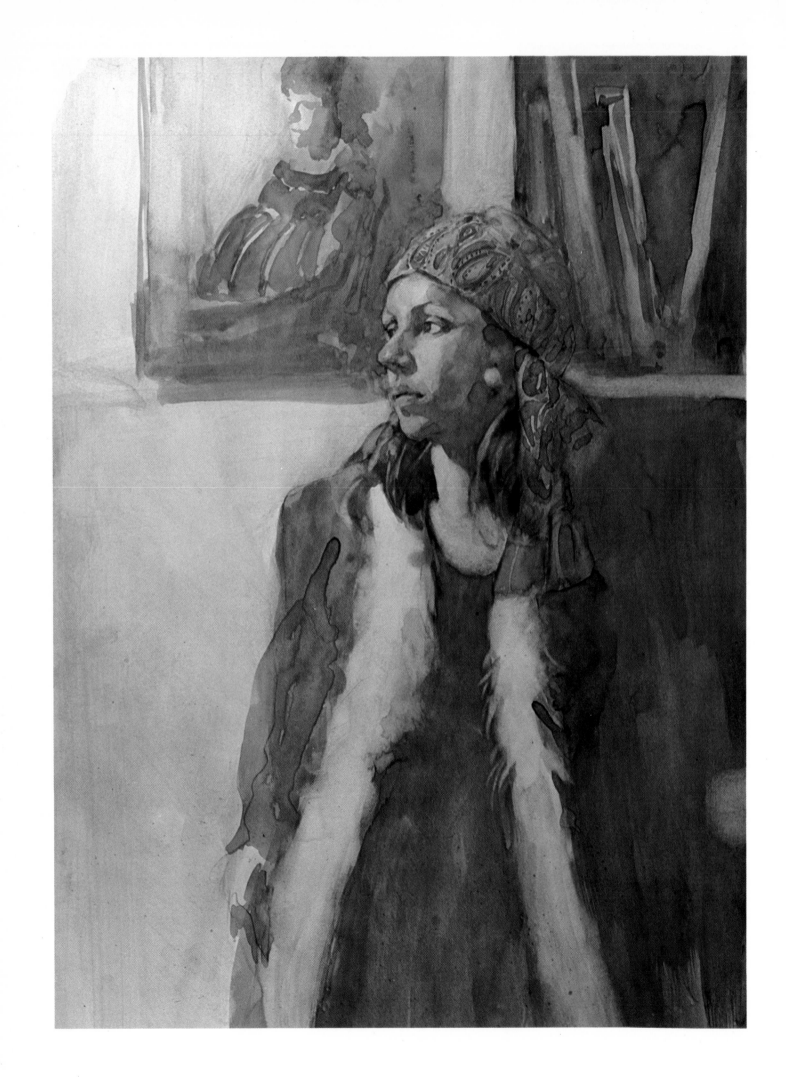

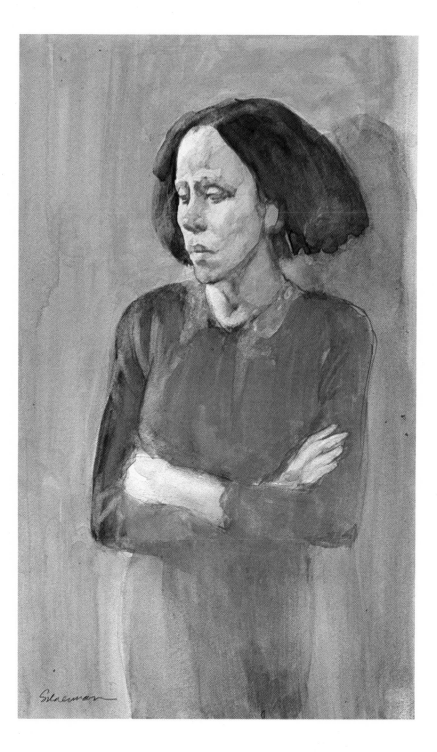

Reflection (above), 1974, watercolor on rag board, 11″ x 14″ (28 x 36 cm), courtesy FAR Gallery. The model for this painting was the subject for two or three other pictures, each showing her with differing expressions and moods. The volatility of her look made painting her a constant challenge. I think the painting was a response to this characteristic. The colors are muted but jarred by sudden changes from warm to cool, as in the background, in the darks of the head, and at the edge of the left side of the body. The face now seems excessively grim, but, everything considered, the picture still holds interest for me.

The Art Student (left), 1976, watercolor on plate bristol rag paper, 14″ x 20″ (26 x 51 cm). The head was rendered by only a few pinks and grays. The rest of the forms were wiped out of the gray-green wash that covered the figure. This is not an accurate or flattering portrait of the student, but I think it's nevertheless an interesting bit of painting.

Portrait of Mike Thaler (above), 1969, oil on pressed paper board, 9″ x 14″ (23 x 36 cm). This was painted at one sitting—the paper board seems to absorb the paint more rapidly than other surfaces. Yet this is one of the more satisfying portraits I've done. The cool palette—blues, pinks, and grays—was selected in part to evoke the feeling of daylight and to heighten the distant gaze of the sitter. The darks are thinly painted— the hair and beard are virtually the original drawing. Most of the "meaty" pigment is located on the lightstruck portions of the face.

The Ceremony (right), 1967, oil on canvas, 25″ x 50″ (64 x 127 cm), collection Jerry and Carol Silverman. This is a portrait of Julio Fernandez Larraz, in a fourteenth-century ceremonial karate skirt, painted when he was still an art student. I think because of the dance paintings I was doing at the time, I was struck by the similarities of movement in the formal, ritual gestures of karate. The aggressive gestures of the arm here could also be found in the exaggerated movements of the burlesque performers. However, the painting now speaks to me more as a reminder of the exotic preoccupations of our culture. The formal elements of the painting—the geometric shapes of the skirt and tunic played against a flat wall and angled floor—were employed to provide a strongly designed format for the glowering face, touched ever so slightly by a glint of apprehension. I was aiming at something like the life-size figure paintings of Manet with their posterlike, emblematic qualities.

The Sand Castle, 1975, oil on canvas, courtesy FAR Gallery. This is one of the first pictures I did in which I felt seriously challenged to simulate the outdoor light on the beach without succumbing to a naturalism that often strikes me as pretty and superficial. I suppose that because I had been so identified with a Rembrandtesque palette of golden lights and umber shadows, outdoor light seems to me to be a kind of rupture with the idea of "art." I think this painting also represents a personal breakthrough in that I've satisfied a need for solidity and weight and at the same time suggested the transient playfulness of time and place.

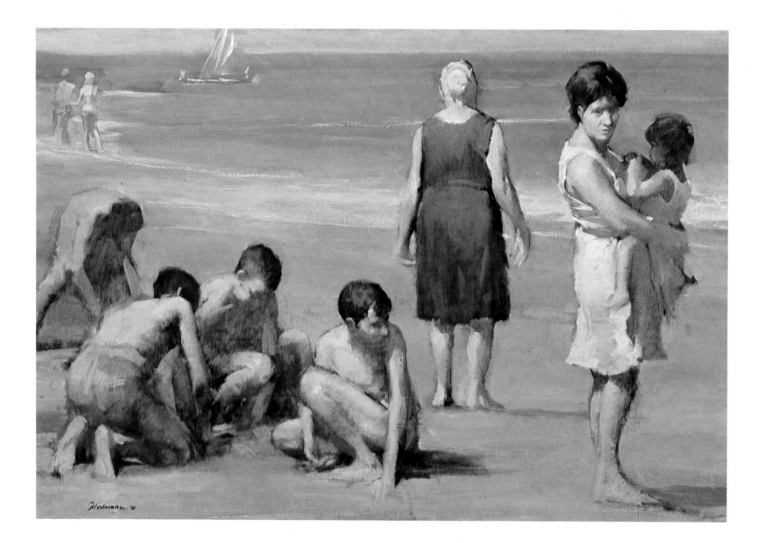

Beach Scene, 1970, oil on canvas, 26″ x 34″ (66 x 86 cm), private collection. This painting is part of my ongoing interest in the beach as a kind of demilitarized zone—a resting place for people in an urban civilization with its anxieties and struggles. It also instantly recalls my childhood, and the somnambulant qualities here may be a direct throwback to my dreamy youth, with its watery, romantic escapism. While the light and color fail on a naturalistic level, they are instrumental in creating the sense of otherworldliness that is the salient quality in this work.

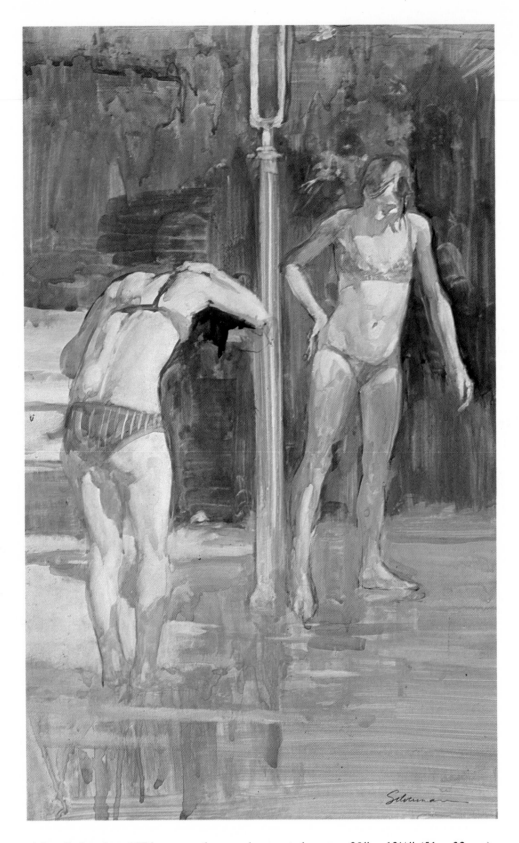

After Swimming, 1974, watercolor on clay-coated paper, 20″ x 12½″ (51 x 32 cm), courtesy Meredith Long & Co., Houston. This beach in Italy has an outdoor shower for washing away the salt water and, more recently, its pollutants. I made dozens of quick drawings of the people who used it, delighting in the device that offered the "two-minute-pose" so dear to art schools, but in a much more living context. As with the Go-Go and burlesque dancers, I found in these bathers a more meaningful way to paint the almost nude body. This watercolor was a study for the one opposite, using a combination of drawings and photographs. I employed a lot of wiping out from the dark green first coat which covered the entire sheet. This is particularly easy to do on this clay-coated paper.

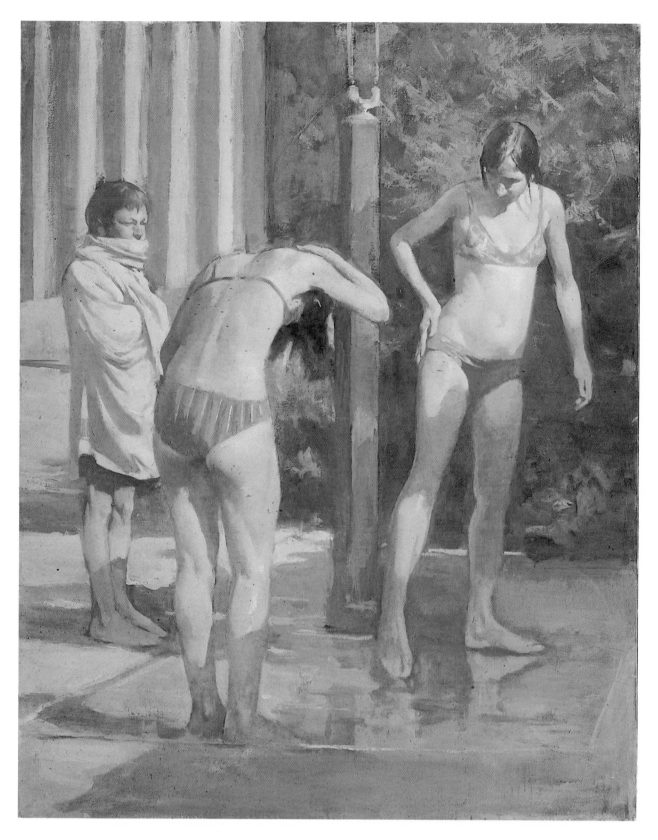

Shower at the Beach, 1975, oil on canvas, 54″ x 42″ (137 x 107 cm), courtesy FAR Gallery. The problem in this relatively large picture was to convert the energy and fluidity that emerged in the watercolor to the more studied, slower oils. Also, I felt that the change in scale seemed to require another level of interest or complexity. Looking through my sketch book, I came across the drawing of the boy, wrapped in a towel, absent-mindedly gazing at the shower.

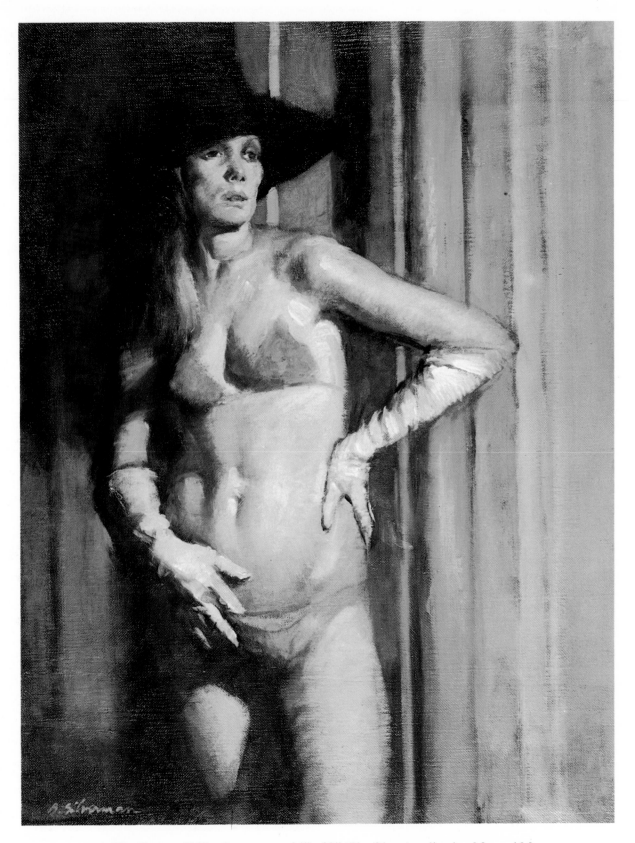

At The Gayety, 1967, oil on canvas, 24″ x 32″ (61 x 81 cm), collection Mr. and Mrs. Dan Dietrich. The theater and its performers have provided the subject matter for art for more than 400 years. The burlesque is a particularly American invention, combining the prurient eroticism of the Victorians with the nonstop, frenetic humor of the Yiddish theater—a perfect lure for me. As a youngster, the burlesque represented for me the ultimate forbidden fruit, barely whispered at. As an adult, I found it tawdry and false, but fascinating nevertheless.

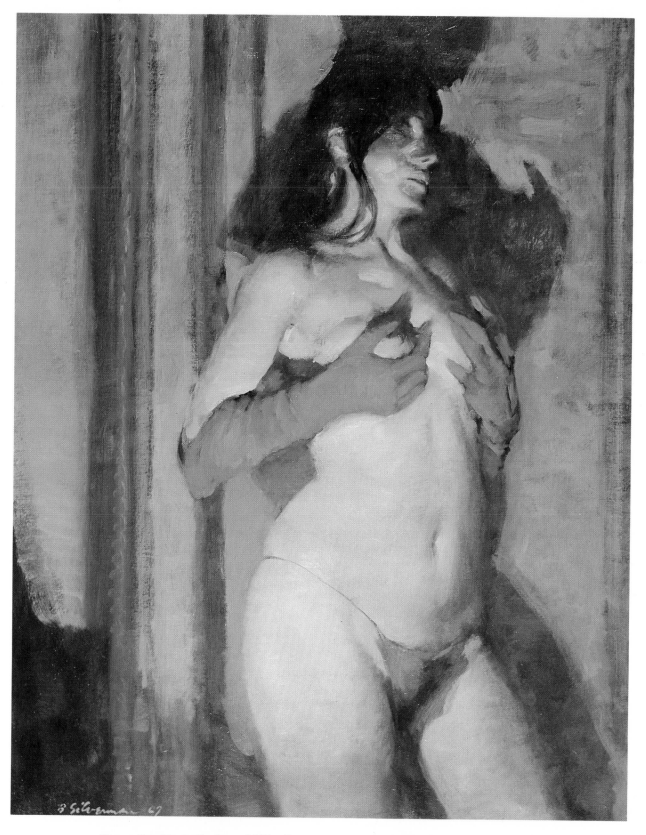

Presenting Rusty Springs, 1967, oil on canvas, 24″ x 32″ (61 x 81 cm), private collection. Included in the same series as the painting opposite, this picture shows another part of the act that was intriguing because of the equivocal nature of the girl's gesture. The underlighting was chosen to exaggerate the theatricality of the pose and to create a cast shadow that, for me, seemed to change the girl's form in a slightly bizarre way. Both paintings were done in the studio using models, though the pose was derived from the actual performance. The paint was applied with a broad stroke, closer to *alla prima* than usual, because I wanted to get it all down at once. This was possibly a response to the fleeting nature of the dance and its constant movement.

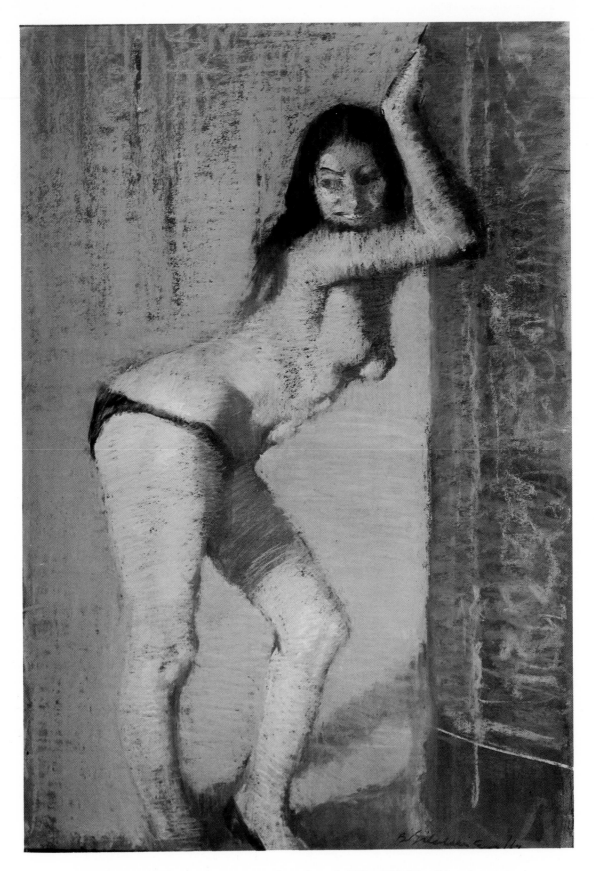

End Game, 1967, pastel on prepared rag board, 20″ x 30″ (51 x 76 cm), courtesy Meredith Long & Co., Houston. This pastel has long been a favorite of mine, despite the explicitness of the look on the performer's face (my current disposition is toward something more elusive) and the sometimes erratic modeling of the body—particularly the legs and hands. But the image is a very strong one, and the color of the background, with its combination of oranges and pinks, is a perfect foil for the darks of the hair and the G-string.

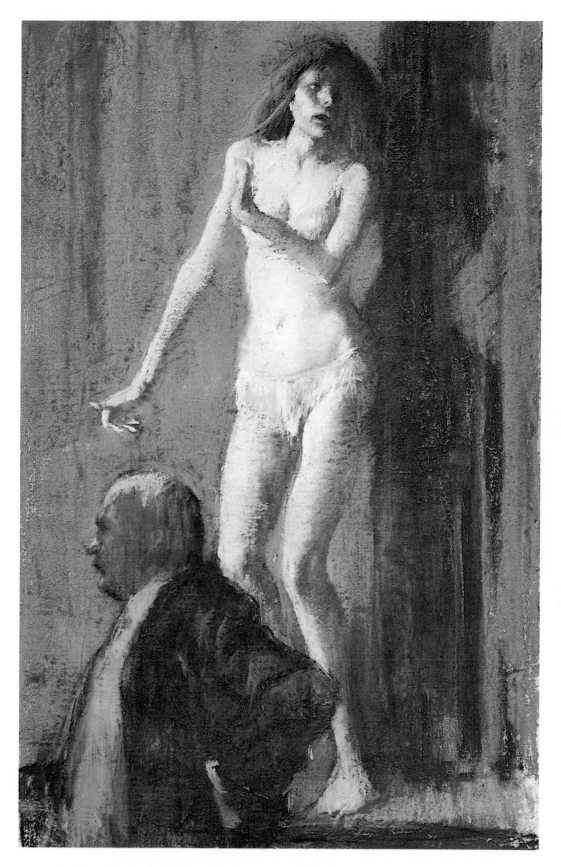

At The Metropole, 1972, pastel on canvas, 18″ x 26″ (46 x 66 cm), private collection. In this picture, the presence of the patron is a device for distancing the observer from the dance. But like many of my pictures on this theme, I have concentrated primarily on the dancer and the disparity between her performance and the look on her face. Like the accompanying pastel opposite, I was also very intent on getting an accurate characterization of her body which is a far cry from the poster image of a sexy girl. The background color, a sort of raw Venetian red, was selected to heighten the sense of something disturbing or unpleasant.

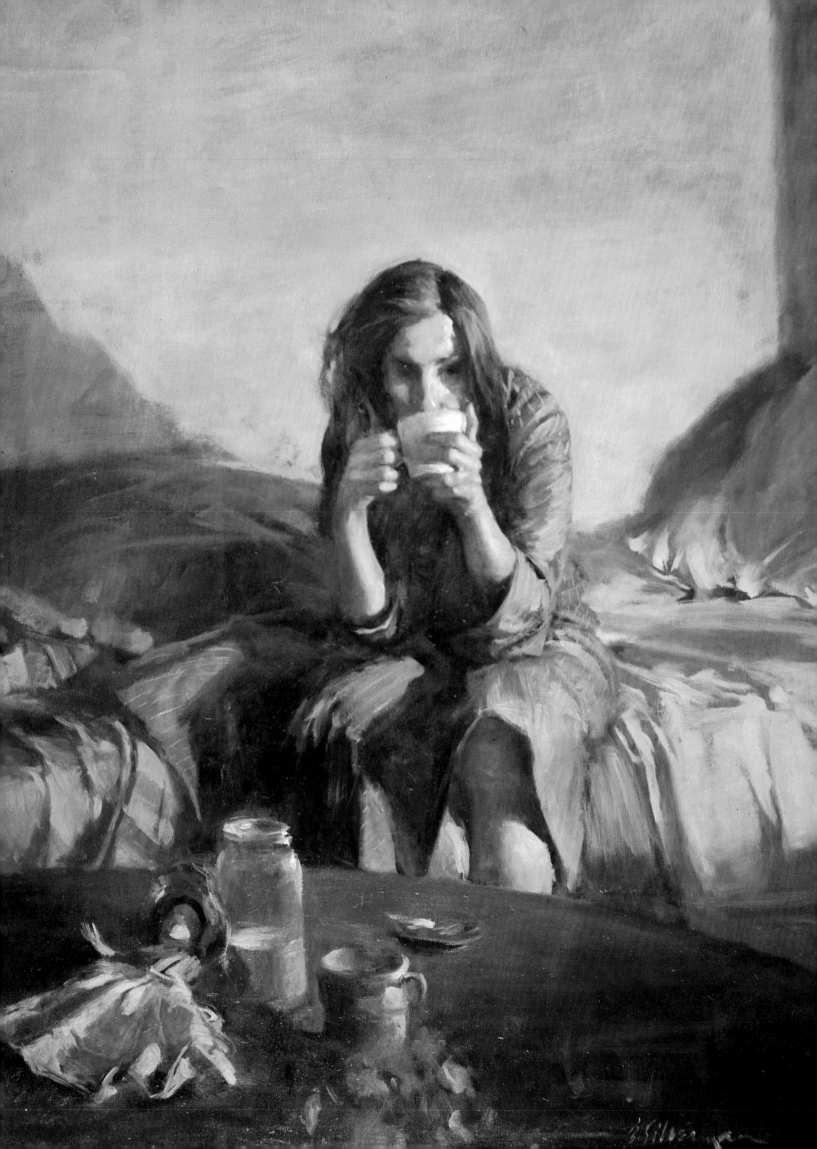

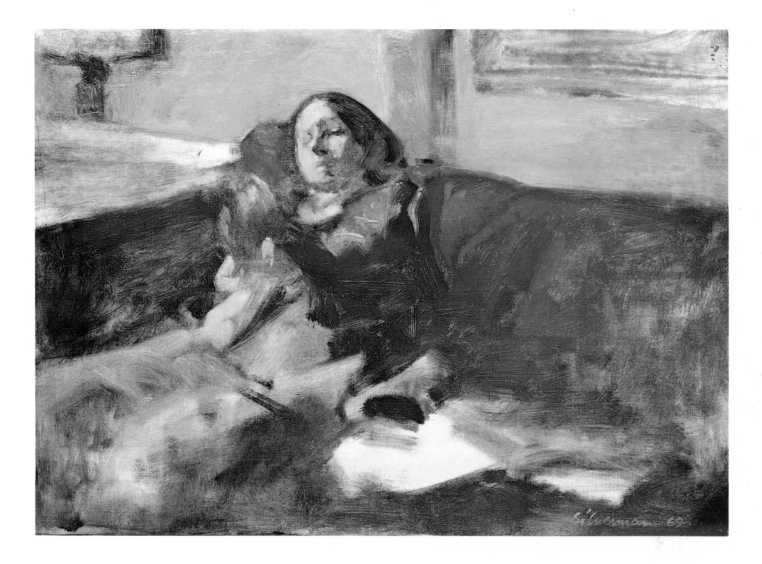

Woman Clipping Her Nails (above), 1967, oil on canvas, 14″ x 20″ (26 x 51 cm), collection Mr. and Mrs. Dan Dietrich. The polar opposite in circumstances and rendering of the painting at left, this was in fact a condensation of all the paintings I'd done of people stretched out on sofas or beds. I'd decided in advance to render only the most minimal of details. In fact, I stopped painting well in advance of what I would have regarded as a finished work. I realized that at this point it said everything, even with forms incomplete and colors almost tinted to watercolor consistency.

The Walk Up (left), 1965, oil on canvas, 35″ x 50″ (89 x 127 cm), private collection. This was painted in the studio from an oil sketch I had done in the model's apartment. I had been doing a lot of studio poses at the time and felt that painting the model in her own environment would present more pictorial options. The pose was arrived at by accident during a break period, as the best poses are. The hunched-over figure of the young woman in the bare room seemed to characterize her circumstances with great force.

Ian Playing The Flute, 1970, watercolor on gesso-coated rag board, 9″ x 10″ (23 x 25 cm), collection Mr. and Mrs. David Reider. This was painted from a drawing of Ian Anderson, the lead performer of the "Jethro Tull" rock group. The drawing focused on the head and hands, and I wanted to keep that quality in the watercolor. As I painted it, however, something else became apparent—that I was interested as much in the shock of red hair just for its own sake, for the curved forms of watery paint, as in the intense concentration of the performer or the anachronism of the classical flute in the hands of the modern rock musician.

Night Song, 1973, watercolor on bristol paper, 14″ x 11″ (36 x 28 cm), courtesy Meredith Long and Co., Houston. The guitar in this picture is more a prop than an integral part of the content. I think the painting is about light and a nostalgic last look at the romance of the 1960s. Even the colors—blue, purple, mauve—are echoes of some half-forgotten pop songs of long ago.

Ballerina At Rest, 1970, pastel on rust Canson paper, 12″ x 18″ (30 x 46 cm), courtesy Meredith Long and Co., Houston. In these two pictures I tackled a subject that has grave potential pitfalls because it is so closely identified with the work of Degas. Nevertheless, I felt strongly enough about this subject—which for me included not only dancers, but all types of performers—that I decided to go ahead with it anyhow. The model was a friend of mine whom I dragooned into posing, though she had just finished a long day of rehearsing. I think that is the dominant quality that emerges from this loosely drawn, but forceful little painting—fatigue and exasperation, yet a determination to go on.

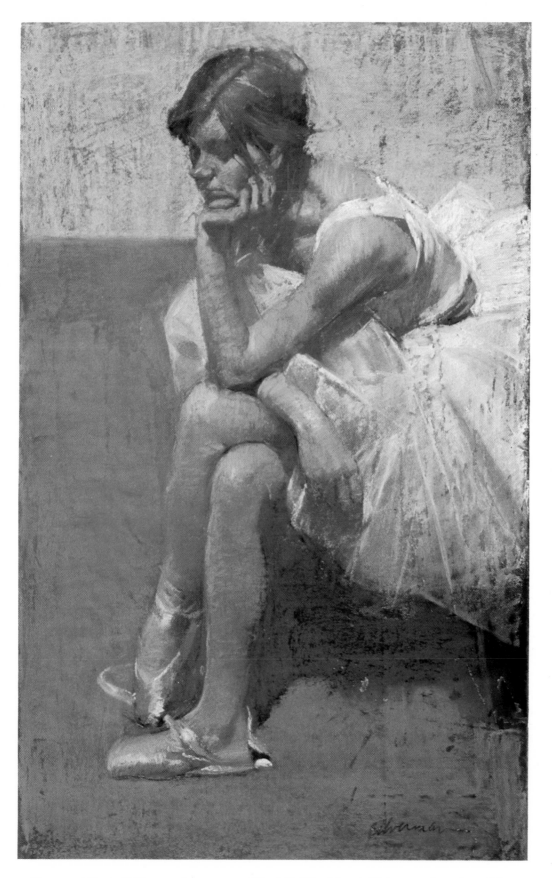

Dancer at Rest, 1975, pastel on canvas, 9″ x 14″ (23 x 36 cm). This second version of the same pose as in the painting opposite was painted several years later from drawings and a photograph. I decided to go after some special properties such as the high-key overhead light that is often found in rehearsal studios. It helps to dramatize the character of the dancer's body and the personality which animates it. I think these formal devices have dovetailed with the explicitness of the portrait and the intimacy of the moment.

Index

Edited by Connie Buckley
Designed by Bob Fillie
Set in 10 point Times Roman by Publishers Graphics, Inc.
Printed and bound in Japan by Dai Nippon Printing Company